LEONARDO DA VINCI

RENAISSANCE MASTER

BARRINGTON BARBER

SIRIUS

SIRIUS

This edition published in 2022 by Sirius Publishing, a division of
Arcturus Publishing Limited,
26/27 Bickels Yard, 151–153 Bermondsey Street,
London SE1 3HA

ISBN: 978-1-3988-2062-3
AD006075UK

Printed in China

CONTENTS

INTRODUCTION

What must it be like to look through the eyes of Leonardo, to see things that are beyond our normal way of viewing the world, to connect so fully, so deeply, that nothing escapes the gaze? To start not from a pre-formulated set of assumptions, but instead to lay nature out before exacting eyes in order to discover what is really there? These were powers that Leonardo possessed and, with his mind engaged and powered by a limitless curiosity, he turned his life into an all-embracing study of anatomy, astronomy, botany, geology, geometry and physics.

Leonardo started life as an artist and craftsman, but he was by nature a scientist as much as a painter. Today science is established as an important discipline, but in Leonardo's day experimental science was virtually unknown and the observation of nature was scorned as an unscholarly activity. Scholarship adhered to the approved classical texts such as those of Aristotle, and empirical observation and experimental methods were yet to develop.

Leonardo's drawing skills were, quite simply, remarkable. Nobody before had observed the worldx in the way he did, nor recorded findings in such meticulous detail or beauty: 'Now do you not see that the eye embraces the beauty of the whole world? . . . It counsels and corrects all the arts of mankind . . . it is the prince of mathematics, and the sciences founded on it are absolutely certain. It has measured the distances and sizes of the stars, it has discovered the elements and their location . . . it has given birth to architecture and to perspective and to the divine art of painting.'

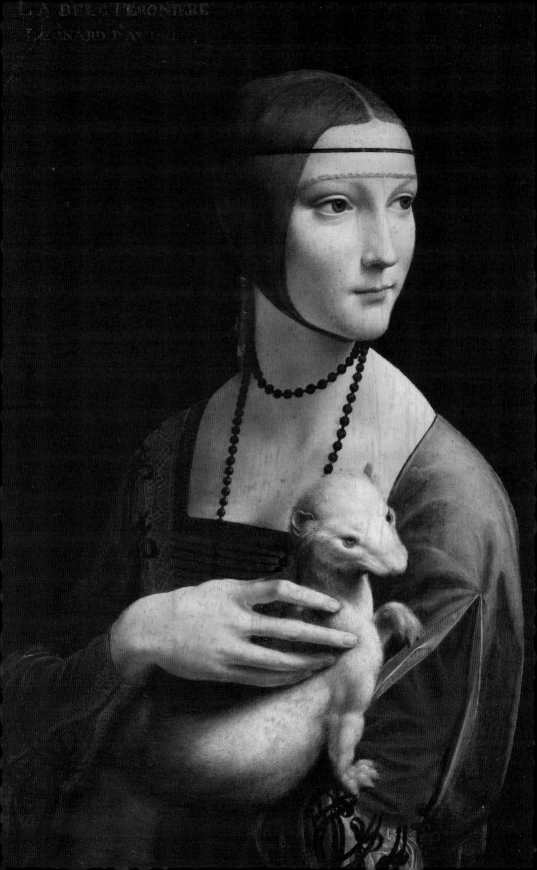

Leonardo created both a new way of looking at nature and a new way of understanding ourselves in relation to nature. In the process he developed a way of thinking that did much to lay the foundations for the modern world, and at the same time he created some of the finest and most profound works of art known to man. He was one of the greatest painters and most versatile geniuses in history, and a key figure in the Renaissance – that great shift in Western culture which still illuminates the world today.

Leonardo's notebooks show what the human mind can do and what the human spirit might rise to if one possesses patience and determination. His tools? His mind, eyes and drawing implement. This book explores the particular conjunction of these three in order to begin to follow in Leonardo's footsteps and start to see through his eyes: 'The eye, which is called the window of the soul, is the principal means by which the central sense can most completely and abundantly appreciate the infinite works of nature.'

HIS STORY

Leonardo was born in 1452, the illegitimate son of Ser Piero da Vinci, a successful notary, and a peasant woman named Caterina. His father took him from his natural mother to be raised in his own family in Vinci, a village near Florence, and it was to Florence that the young Leonardo was inevitably drawn when his prodigious talents became evident. His father arranged for him to be apprenticed at the age of twelve to Andrea del Verrochio, one of the greatest of Florence's artists. In Verrochio's workshop were other illustrious artists, including Botticini, Perugino and Lorenzo di Credi.

This suited him perfectly. As Leonardo's biographer Vasari, a painter in his own right and an astute observer of his contemporaries, said:

'The boy was delighted with his decision, and he began to practise not only the branch of the arts but all branches in which

design plays a part. He was marvellously gifted, and he proved himself to be a first-class geometrician in his work as a sculptor and architect.'

Leonardo studied little Greek or Latin, a drawback in the era of the Renaissance which was founded on the culture of Greece and Rome. The Renaissance celebrated the rebirth of the classical world and all the knowledge that world contained, but Leonardo's access to it was limited by his lack of education. He made an attempt in his thirties to learn Latin on his own, but all his notebooks are written in a robust style of Italian. This lack of Latin, however, proved to be an advantage as, unable to read the teachings of classical scholars, Leonardo was able to make the point that his work was not rooted in speculation but in first-hand observation:

'To me it seems that all sciences are vain and full of errors that are not born of Experience, mother of all certainty . . . that is to say, that do not at their origin, middle or end, pass through any of the five senses . . . where reason is not, its place is taken by clamour. This never occurs where things are certain. Therefore, where there are quarrels, there true science is not . . . wherever it is known controversy is silenced for all time.'

Leonardo had a fiercely independent view about almost everything. A sentence that appears in the first edition of Vasari's writings on Leonardo (but disappears thereafter) indicates how Vasari saw his thinking:

'Leonardo was so heretical a cast of mind, that he conformed to no religion whatever, accounting it perchance much better to be a philosopher than a Christian.'

Under the tutelage of Verrochio, Leonardo's talents were quick to flower. Arriving in 1464 to serve an apprenticeship, he remained with him as an assistant for several years. From about 1477 to 1482, Leonardo had his own studio in Florence and worked under the patronage of Lorenzo de' Medici, known as Lorenzo the Magnificent. Through him, Leonardo was to gain access to one

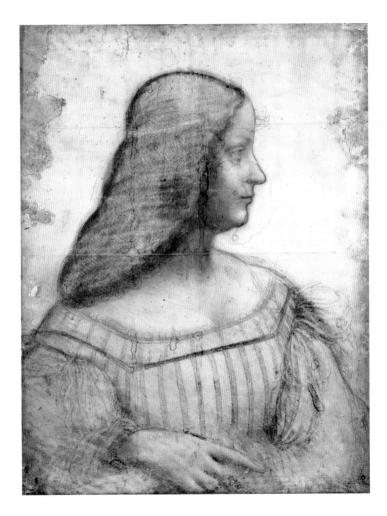

of the most influential institutions of the Florentine Renaissance
– the Platonic Academy. Marcilio Ficino, a renowned scholar and
philosopher of Leonardo's time, had translated the works of Plato
and other classical philosophers from Greek to Latin to make them
more available to scholars in Europe. Ficino would have read the
work of the philosopher Plotinus and it is Plotinus that Leonardo
echoed when he talked of painting being 'a philosophy, because it
deals in movements of the bodies in the vividness of their actions'.

Leonardo left Florence around 1482 to become court artist for Lodovico Sforza, Duke of Milan and the city's ruler. As a fully trained artist, he was expected to have knowledge of many things beside painting and sculpting.

One ambitious project that he embarked upon was a huge statue of the Duke of Milan's father mounted on a horse. It is claimed that Leonardo worked on a full-size clay model for casting for sixteen years, only to have the allocated bronze turned into cannons during a time of war, and the invading French troops use the clay model for target practice. The drawings, however, are still intact, and include ingenious schemes for the casting of this monumental piece. Interestingly, however, when Leonardo first proposed the idea for the construction of the great horse to the Duke of Milan, his letter concentrated not so much on his skills as an artist as on his competence as a military engineer:

'Also I will make covered chariots, safe and unattackable which, entering among the enemy with their artillery, there is no body of men so great but they would break them.'

Where Leonardo learnt his knowledge of engineering nobody knows; perhaps his research into the laws of mechanics and his creative mind provided all that was required. Mechanics was certainly an abiding interest. He made designs for all kinds of weaponry, and drawings of military bridges, forts and other defences. He drew plans for ships with double hulls so that if damaged they would stay afloat. He even designed methods for piercing ships' hulls and diving suits in which to test this. It was also during this period that Leonardo's drawings of the first flying machines began to appear. But he never neglected his art. In the notes and sketches for a book on light and shade begun at this time, his eye is as penetrating as ever: 'The air as soon as there is light is filled with innumerable images to which the eye serves as a magnet.'

In 1490 Leonardo collaborated with the poet Bernado Bellincioni in the creation of a court masque. For this, an enormous

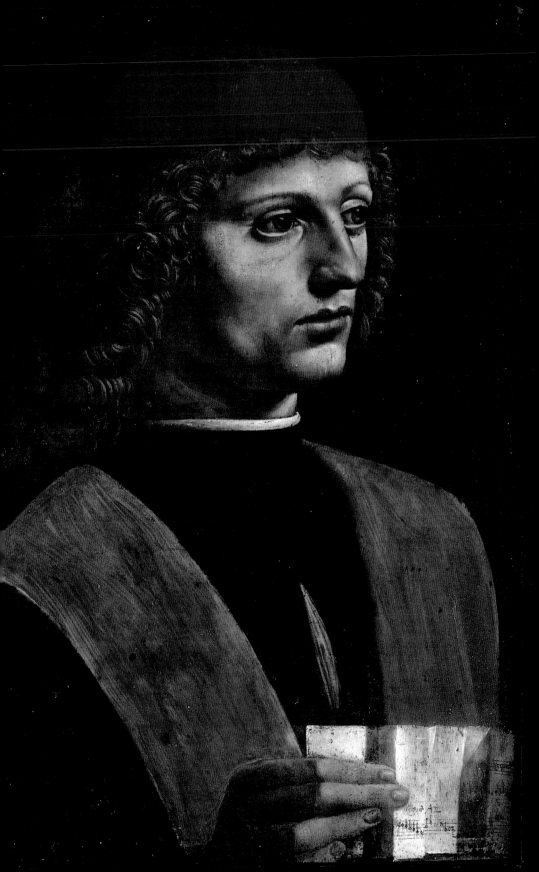

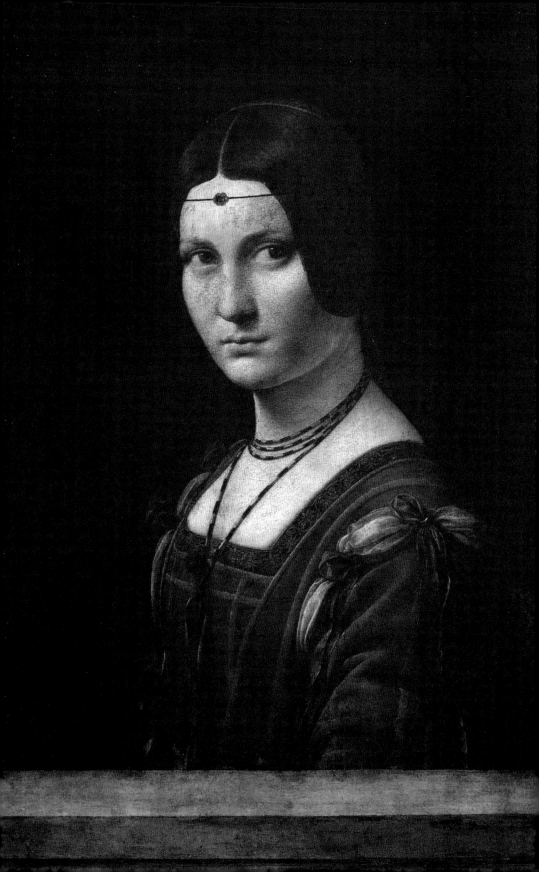

gilt hemisphere that opened to reveal personifications of the planets was created. For a man who relied on his eyes so much, the power of the sun was of central importance: 'The sun has substance, shape, motion, radiance, heat and generative power: and these qualities emanate from it without its diminution.'

During this time Leonardo continued to paint and began work on *The Last Supper*. His notebooks suggest that he was seeking somebody to model as Christ. It was observed at the time, by those who watched Leonardo working, that he sought out the people he wanted to paint where he knew they would be: 'troubled or serene, old or young, irate or quiet . . . he observed their manners, dresses and gestures; and when he found what fitted his purpose, he noted it in his little book which he was always carrying at his belt'.

In the refectory of the monastery of Santa Maria delle Grazie he would sometimes work on *The Last Supper* mural from sunrise to sunset, never pausing to stop. He would then not paint for days on end, yet would visit the mural every day, standing in front of it, reflecting and considering. He would climb the scaffolding only to add the smallest of brush strokes.

None of this could have been done if Leonardo had used the fresco technique traditionally employed for wall paintings. This requires the artist to paint on to damp, freshly laid plaster, which means working quickly. But Leonardo did not use this method; his was a slow, reflective approach as his style was dependent on the careful modulation of light and shade. He developed a new technique that involved coating the wall with a compound he had created. Unfortunately the compound, which was supposed to hold the paint in place and protect it from moisture, did not work as he expected.

What remains today of the mural reveals the clear indication of Leonardo's ideas on composition. Christ and his apostles were usually shown in a line, with Judas set apart. Leonardo painted the apostles in several small groups, each apostle fully realized as an

individual responding in a different way to Christ's announcement that one of them will betray him. The composition, in which the space recedes to a point behind the head of Christ, is one of the great examples of one-point perspective.

Mathematics was also a great love of Leonardo's, and in 1497 he illustrated *De Divina Proportione* for Fra Luca Bartolomeo de Pacioli. It was, undeniably, Leonardo's mastery of proportion and perspective, as revealed to him by his understanding and acute insight into mathematics, that enabled him to create works of such realism:

'Every part of the whole must be in proportion to the whole . . . I would have the same thing understood as applying to all animals and plants . . . Let the pit of the throat always be over the centre of the joint of the foot on which the man is leaning. The leg which is free should have the knee lower than the other, and near the other leg. The positions of the head and arms are endless . . . Still, let them be easy and pleasing, with various turns and twists, and the joints gracefully bent, that they may not look like pieces of wood.'

Leonardo's participation in a debate at court between representatives of the arts and sciences is also mentioned by Vasari, who considered Leonardo's powers of argument to be supreme. In the cut and thrust of debate, Leonardo 'silenced the learned and confounded the liveliest intellect'. Given his profound insights into the worlds of both art and science, there can have been little doubt of Leonardo's authority.

In 1499 the French army invaded Lombardy and took control of Milan. Some months later Leonardo left the city and travelled to Venice via Mantua. In Venice, the authorities employed him as an engineer, seeking his advice on how best to strengthen their military defences.

By 1500, Leonardo was back in Florence. His work had made him famous and he was received by his own people with great honour and acclaim. The early work Leonardo had done in Florence

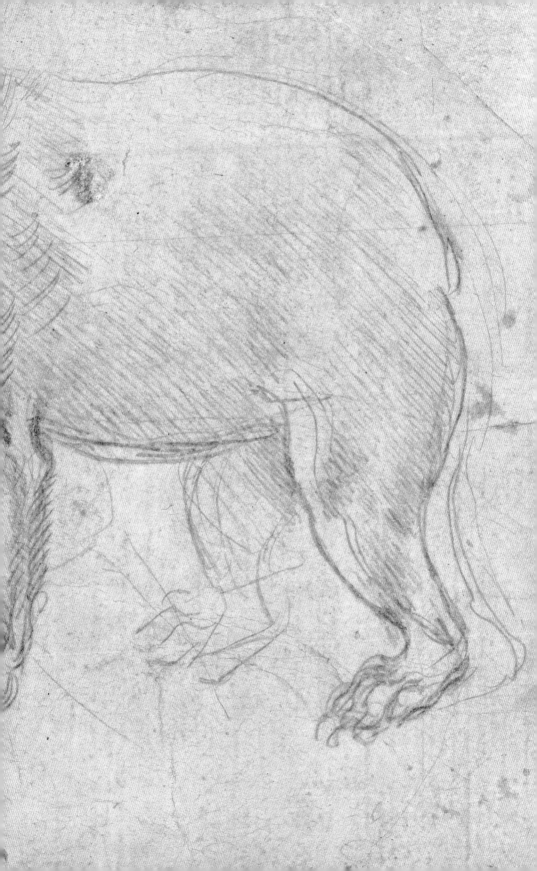

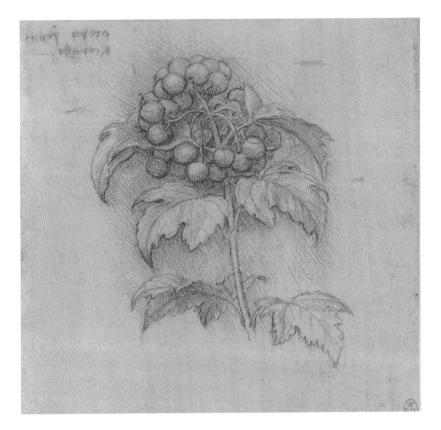

before he left for Milan had strongly influenced a number of young artists, including Sandro Botticelli and Piero di Cosimo, and after his departure these artists had become the leaders of the next generation of Florentine painters. The work Leonardo was to create after his return to Florence would inspire yet another wave of artists, including Andrea del Sarto, Michelangelo and Raphael.

Leonardo's questing mind would not allow him to rest. Again he left Florence and for a year he served Cesare Borgia, the able and ruthless military leader, in his campaign to subdue the petty despots of Romagna. Leonardo had by now taken up the study of topography and geology and Borgia made Leonardo his chief engineer, giving him the authority to take whatever resources he needed to strengthen Borgia's fortifications. Inevitably, Leonardo had many ideas of how this might be done. By early 1503, the campaign was over; Borgia went back to Rome and Leonardo again returned to Florence.

In October 1503, Leonardo was commissioned by the city council to paint a large mural on one of the walls of the new Sala di Gran Consiglio in the Palazzo Vecchio. Leonardo's subject matter was to be the Battle of Anghiari, when the army of Florence had defeated Milan in 1440. His sketches showed a cavalry battle with tense soldiers, leaping horses and clouds of dust. He broke completely with what had been attempted before, filling his painting with violent movement as the figures of men and horses clash and tumble over one another. He described some of the scenes in his notebooks:

'The figures in the foreground you must make with dust on the hair and eyebrows . . .The conquerors you will make rushing onwards with their hair and other light things flying in the wind, with their brows bent down . . . make the conquered and beaten pale, their brows raised and knit, and the skin above their brows furrowed with pain . . . And make some one shielding his terrified eyes with one hand, the palm towards the enemy.'

Sadly, the wall painting no longer exists. Its general appearance is known from Leonardo's sketches and from copies made by other artists, including Rubens. Amazingly, while working on *The Battle of Anghiari*, Leonardo was also painting another of his great masterpieces; the *Mona Lisa*. According to Vasari, he worked on the *Mona Lisa* for four years, claiming it was unfinished. Whether this was what he genuinely thought or whether he could not bear to part with it, the painting went with him everywhere.

There is a story that Vasari tells of how Leonardo kept the famous smile of his model alive: 'He retained musicians who played and sang and jested in order to dispel the melancholy that painters tend to give their portraits.'

In 1506, Leonardo returned to Milan. Study, most especially of geometry, became of paramount importance to him as he grew older. His notebooks are filled with examples of his trying to solve longstanding geometrical problems – and succeeding. In 1509 he wrote, 'Having for so long time sought to square the angle . . . now

in the year 1509 on the eve of the calends of May, I have solved the proposition at ten o'clock on the evening of Sunday!'

Leonardo's studies continued into all areas of natural philosophy. The famous anatomist Marcantonio della Torre helped him in his research and it was at this time that Leonardo produced the following note, with a wonderful drawing of a baby in the womb (see p.67) to accompany it: 'It lies continually in water, and if it were to breathe it would be drowned, and breathing is not necessary to it since it receives life and is nourished from the life and food of its mother.'

Political changes meant that in 1512 Leonardo left Milan for Rome in the hope of gaining greater patronage under the two sons of Lorenzo de' Medici, the man who had done so much to support him in his earlier life. Giuliano de' Medici was happy to welcome Leonardo to Rome, but died shortly afterwards. Leonardo was left feeling old and neglected; he wrote, 'The Medicis made me and ruined me.'

Fortunately, Francis I of France, a man with a genuine love of learning and art, persuaded Leonardo to come to France. In 1516 he was installed in a small castle at Cloux near the royal palace at Amboise on the Loire. There, despite suffering the partial paralysis of his right hand, he continued to draw and teach, producing for Cardinal Luigi of Aragon drawings which had lost none of their vitality and closely observed details.

Three years later, on 2 May 1519, Leonardo died. Vasari certainly did not exaggerate when he wrote: 'In the normal course of events many men and women are born with various remarkable qualities and talents; but occasionally, in a way that transcends nature, a single person is marvellously endowed by heaven with beauty, grace and talent in such abundance that he leaves other men far behind. All his actions seem inspired and indeed everything he does clearly comes from God, rather than from human art. Everyone acknowledged that this was true of Leonardo da Vinci.'

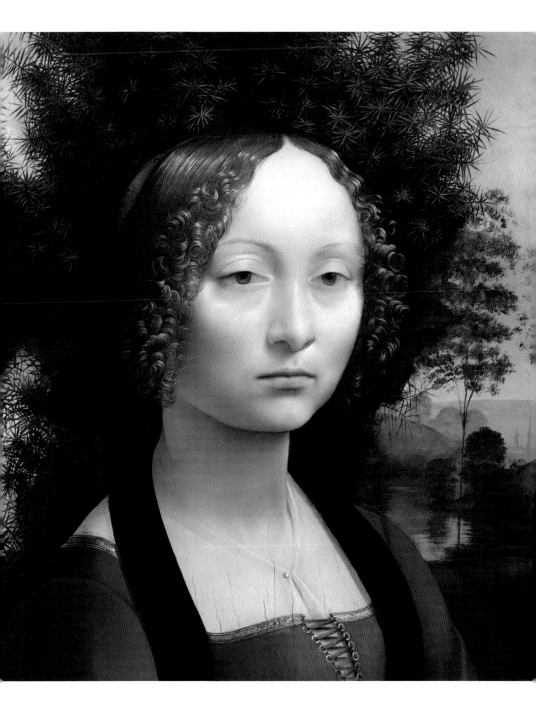

1

THE
NATURAL
WORLD

Early in his career, Leonardo compiled an inventory of his works. At the top of his list was the item 'Many flowers copied from nature'. Leonardo's botanical interest lasted throughout his life, with studies on growth and form regularly appearing in his notebooks.

As both artist and scientist, Leonardo's approach was based on an empirical study of nature. As an artist Leonardo was interested in representing nature's inherent beauty, and as a scientist he was concerned with the universal laws which lay behind nature's expression: 'The senses are of the earth; reason stands apart in contemplation,' he wrote. It is this mix of analysis and reflective contemplation that is one of the most noticeable features of Leonardo's work.

Leonardo's drawings, and the writings that accompany them, show his interest in how the elements interacted and how that interaction influenced the natural world. His notebooks are full of observations about the interplay of the elements evidenced in the movement of water, rocks and clouds. Water in particular fascinated him and he hoped to discover the most fundamental of nature's laws by the study of the movement of water through earth and air: 'Water is the driver of nature . . . It is the expansion and humour of all vital bodies. Without it nothing retains its form. By its inflow it unites and augments bodies.'

Leonardo also created ways to represent more accurately and naturally the suggestive interplay of light and mist, with his renowned *sfumato* technique of softly modelled tones: 'The painter can suggest to you various distances by the change in colour produced by the intervening atmosphere between the object and the eye.'

To Leonardo there was no separation between science and art. He strove for and achieved a masterly realism in the balance and harmony of all his work.

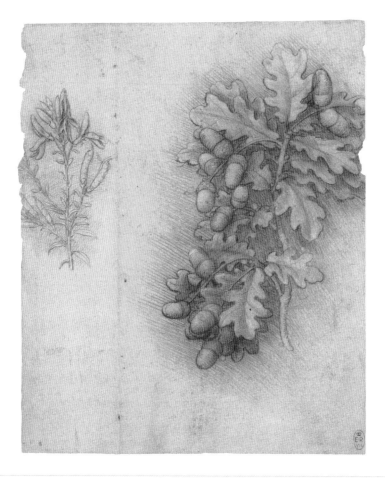

SPRAYS OF OAK LEAVES AND ACORNS

Leonardo's drawings of plants are as informative as botanists' drawings, but are given greater life by the brilliance of his work. There is no doubt that this study is drawn from life; the dense chalk lines give plasticity and form to the leaves and acorns, almost like a *bas-relief* sculpture. This also gives it a rather formal, heraldic character while losing nothing of its naturalness. The drawing may have been used as a basis for the foliage in the painting *Leda and the Swan*, or possibly for a garland above *The Last Supper*. The sprig of dyer's greenwood on the left is also a wonderfully accurate drawing of the plant.

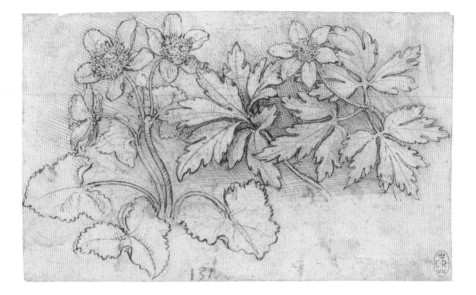

STUDIES OF TWO PLANTS - *CALTHA PALUSTRIS* AND *ANEMONE NEMOROSA*

Dated around 1508–10, this image is drawn in pen and ink over faint black chalk. The elegance of the hatching and the precision of the outlines of the petals and leaves make this a good botanical study as well as a work of art; the shapes are precisely drawn, but at the same time the forms are naturally positioned and not presented as a diagram.

It has been suggested that the care with which it was drawn might have been in order to allow an engraver to transpose the image on to plates. At this period of the Renaissance many artists were preparing drawings for reproduction as engravings, partly because of the increased income that this could generate, and also to supply to students in other parts of Italy who were eager to learn from renowned masters. Indeed, to this day artists use these drawings to test their ability.

ARNO LANDSCAPES

This accomplished drawing of the landscape of Tuscany near the River Arno, dates from around 1473. Before Leonardo, a drawing of landscape without human figures and symbolism would have been unthinkable. The first complete painted landscape is credited to Peter Paul Rubens, almost two hundred years after da Vinci's drawing was made. Roman frescoes of landscapes survive, but they were unknown at Leonardo's time and in the preceding seven hundred years.

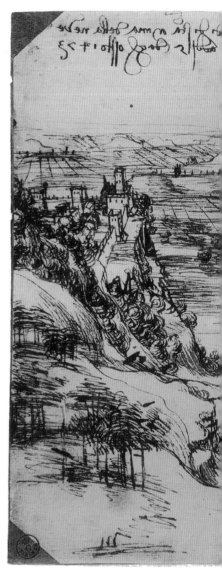

Leonardo's fluent technique is ahead of its time in the handling of rocks, rivers and vegetation. The pen-and-ink lines over a partially erased pencil sketch are simply drawn as horizontal strokes to suggest tree branches and leaves; lines following the contours of the landforms suggest the solidity of the earth. Closely drawn horizontal lines efficiently suggest reflections on the surface of the water, and Leonardo's understanding of perspective means that he makes the tonal effects of the pen lines less prominent as they recede into the distant landscape. With multiple lines of hatching, he builds up the large, closer rocky shapes and convinces the eye of the solidity of the terrain. Where he has drawn many lines converging to represent swiftly flowing water, the eye perceives substance and movement. The delicacy of the smaller

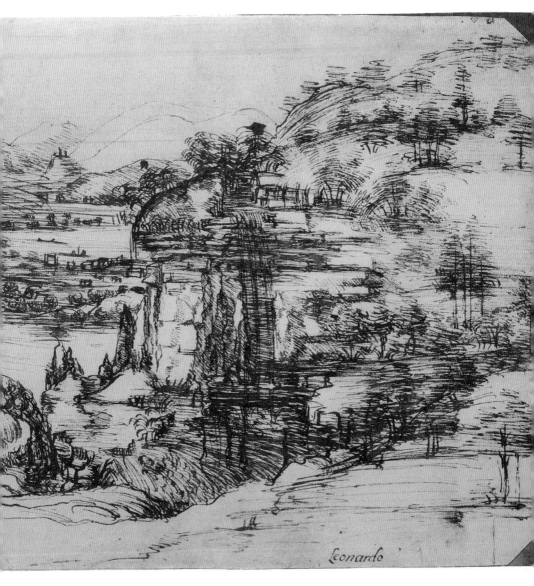

objects in the landscape – the fortified buildings and the dark shapes of floating boats – brings them into prominence.

The controlled vigour of the drawing entirely satisfies, and one can only speculate how Leonardo's talent must have overwhelmed his contemporaries when they saw the effectiveness of this sketch.

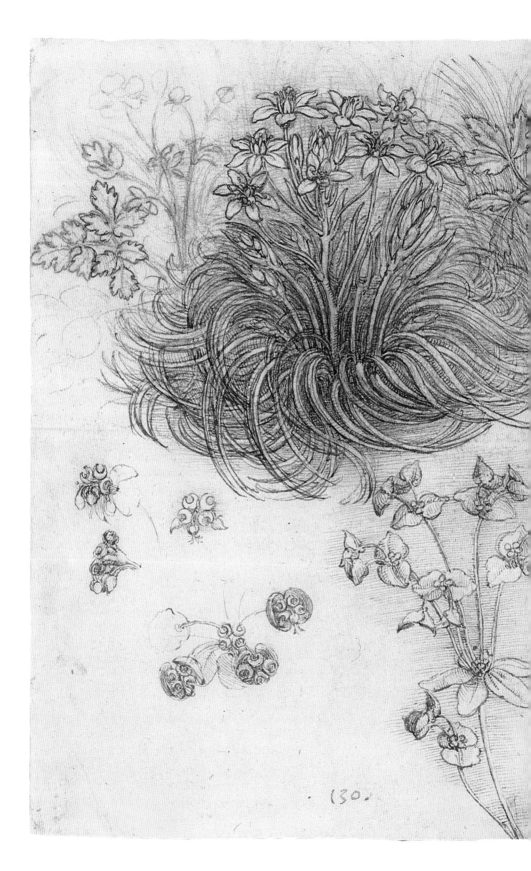

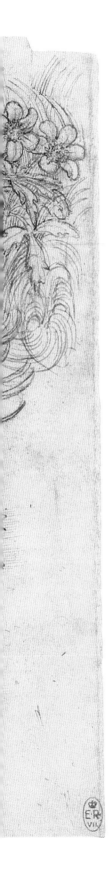

STAR OF BETHLEHEM

An exquisite drawing of plant form, this Star of Bethlehem (*Ornithogalum umbellatum*) is dated around 1506–8 and is in pen and ink over red chalk underdrawing. The details of the blooms are clearly rendered and the intricate swirls of leaves are similar to some of Leonardo's studies of water movement (see p.59), making a nice connection between the plant, which depends on water, and the shapes and patterns of swirls of water as they pass through constricted openings.

This image – so finely observed that modern botanists can readily identify the plant – shows that Leonardo welcomed the problems of investigative drawing. There was nothing he could not turn his mind and hand to, and by observation, drawing and investigation of the facts he derived enormous pleasure and satisfaction from the mysteries of life.

BRANCH OF BLACKBERRY

This drawing is in red chalk, touched with white on a reddish prepared paper, and is probably from the same sketch book as the oak leaves and acorns drawing on p.26, but dated 1504–8. It is related to the studies for *Leda and the Swan*, in which it also appears.

The feeling of growth and form in these drawings often gives a tactile impression; one can understand why at different times there was some belief that these were meant to be made into relief carvings. This is not necessarily so, however; some experts think that a certain amount of touching up was carried out by, for example, Leonardo's student Melzi, at some later time. Nevertheless, both the beauty of form and the perception of the growth of these berries and leaves are very fine and show a clear understanding of the plant's habit.

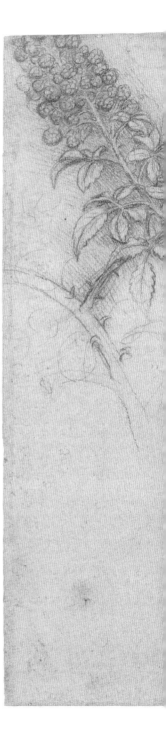

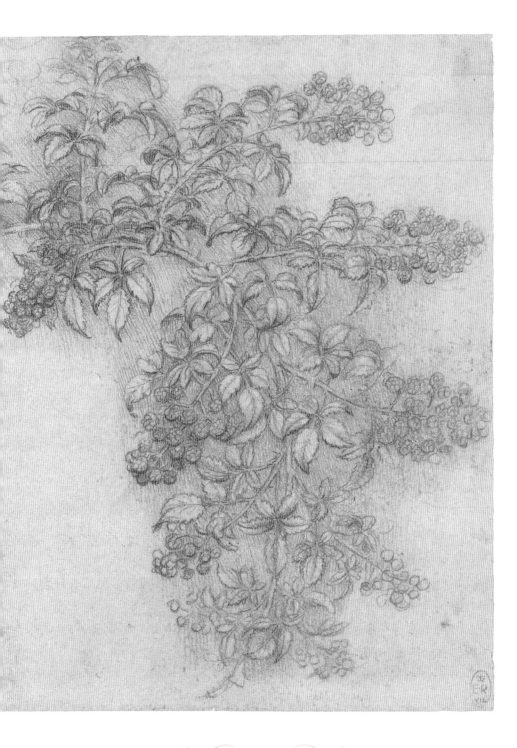

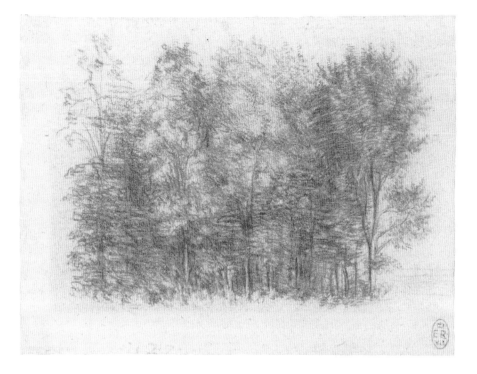

COPSE OF BIRCHES

Kenneth Clark, a distinguished scholar of Leonardo, said of this drawing: 'Technically it is a miracle.' How, he asks, could Leonardo sharpen a piece of red chalk so finely that he could show the boughs and leaves of the trees with such luminous clarity? The notebook containing this drawing dates from 1498–1502 and contains other similar drawings of trees in groups. It is not known if it was produced for any particular painting, but it is one of the finest groups of trees ever drawn. Other artists certainly knew of it at the time and there are pieces of work in Milan by some of Leonardo's followers that have very similar trees painted in them. The brilliance of this group of trees, giving just the right amount of tactile information with its *chiaroscuro*, and the skilful handling of clumps of leaves feathering off the branches, is a valuable record of the talent and perception of this great Renaissance artist.

HEADS OF TWO TYPES OF RUSH

This pair of drawings from around 1508 resembles other scientific illustrations with accompanying notes. The finely wrought method of pen and ink over black chalk suggests that they were intended to be translated to copper engravings, so that they could be reproduced. Leonardo wrote all the notes in his notebooks from right to left, in a manner of mirror writing, and as such the words could have been easily transferred for printing. Leonardo, who taught himself to write, was left-handed which could explain this unorthodox form of writing: when writing for public gaze, however, he would write as normal, from left to right.

The two rushes may have been intended for a 'discourse on herbs' planned as part of a book on painting. The emphasis in these drawings on the elements of flower and seed reinforces this idea.

GEOMETRIC FIGURE AND BOTANICAL DRAWING

In this drawing, executed in approximately 1487–1490, Leonardo used pen and ink and wash on paper – a combination that allowed for the precision of his customary scientific approach to botanic details while also rendering the fine gradations of light and shade on the petals. It is clear that his main interest here lay in the flowers, for the leaves and stems are addressed with less attention to their tonal values of light and shade, while the left-hand flower appears almost sculptural in the intricacies of its form. The surrounding vegetation is lightly indicated, while hatched lines behind the flowers and leaves give a suggestion of background; their regularity is typical of Leonardo's meticulous treatment of even minor elements of a drawing. Above the flowers is a geometric figure, while below them, Leonardo has drawn an entirely unrelated design for soldering equipment, with notes about a technique for soldering a lead covering on to a roof.

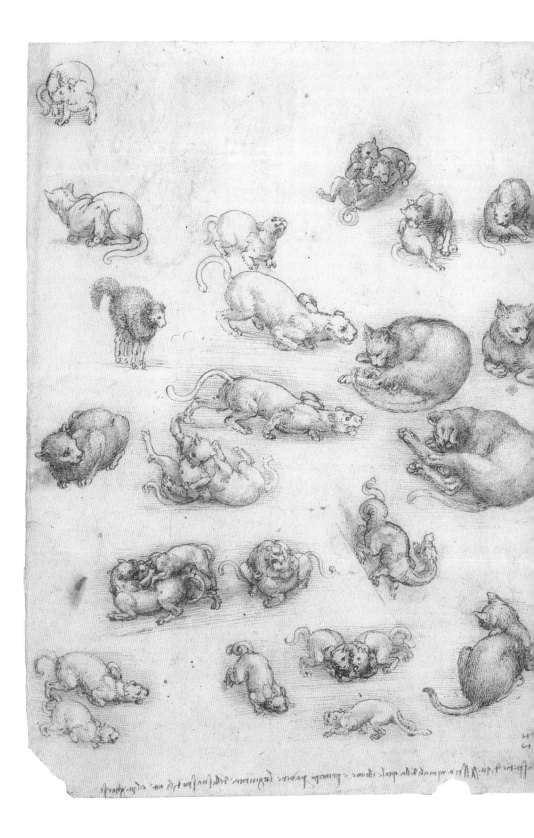

STUDIES OF CATS, A DRAGON AND OTHER ANIMALS

This exceptional sheet of studies, mainly of cats, is from Leonardo's last years. It is known that he was suffering from ailments which partially paralyzed him, but his drawings are as lively and fresh as the ones he did when he was a much younger man. These pictures, dated around 1515, are in pen, ink and wash over black chalk. They show the remarkable variety of cat movements and are similar to another sheet showing the movement of horses. The studies show cats and kittens playing, one cat with its fur erect, and cats stalking, washing and sleeping. It is obvious that these are all drawn from direct observation and that Leonardo's speed and skill of drawing survived despite his advancing years. The liveliness and freshness of these magnificent sketches reveal that artistically the power of youth persisted; one cannot fail to be delighted by the brilliant sense of movement and life in these drawings.

It is also very interesting to see how the drawing of the dragon, by using the analysis of the movement seen in the cats, suggests the powerful movement of this mythical creature.

HORSE'S HEAD

This vigorous pen-and-ink drawing of a horse's head, dated c.1503–4, gives an idea of the emotional power which might have been shown in the great mural that Leonardo was commissioned to do for the Palazzo Vecchio in Florence. This was a depiction of the Battle of Anghiari, which the Florentines wanted on one wall of a hall in their main government building, with a similar painting by Michelangelo of the Battle of Cascina opposite. Because of political changes in the governing body of Florence and calls from Milan and Rome for the services of the two artists, the project was begun, but never finished by either of them. This painting of a battle scene would have been quite unlike anything produced before because of its unprecedented expression of the confusion and ferocity of conflict. All the drawings still in existence for this work show a powerful, moving tableau of rearing horses and shouting warriors. This passionate charge was called 'beastly madness' by Leonardo, and he represented this in his drawings.

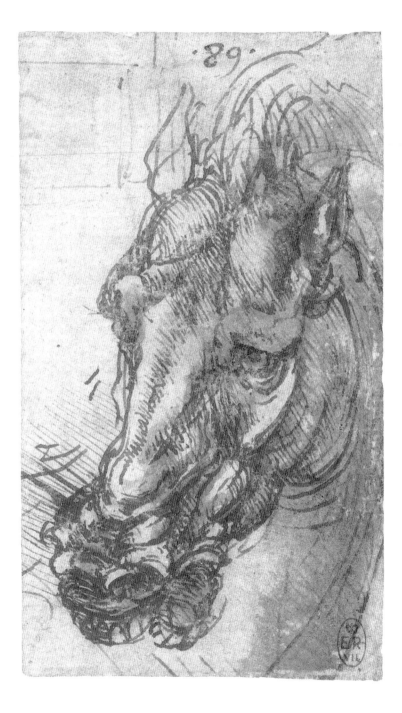

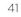

HINDQUARTERS OF HORSE AND TWO OTHER VIEWS

These sketches, from around 1490, show Leonardo's meticulousness in painting or sculpting animals. There are scores of his drawings in existence of horses in every posture. Here he concentrates on the hindquarters, with a careful drawing of the details of one back leg, and the shoulders from a semi-rear viewpoint. The medium is silverpoint, resulting in very fine lines. The vigour of these drawings is evident in the incisive outline with its flowing strokes.

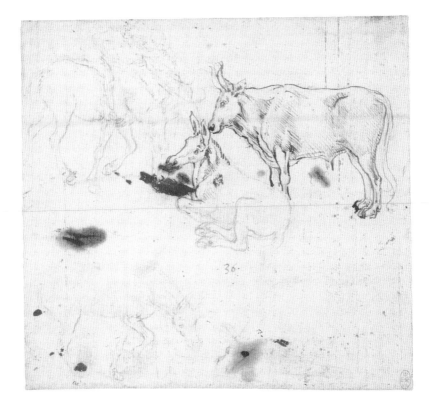

AN ASS AND A COW

This drawing of an ass lying down and a cow standing behind, dated around 1478, brings to mind the nativities of Christ which were so much a part of the Renaissance artistic endeavour. Perhaps this is connected with the great *Adoration of the Magi* scene (see pp.82 and 124) which was never completed, like so many of Leonardo's projects. Though he could work rapidly, his exceptionally wide range of interests, such as scientific studies, artistic masterpieces, notes on his work and studies for various proposed treaties on mathematics, painting, fortification and weaponry, must have made it difficult to keep all his projects going at the same time.

This beautiful little group of animals looks like a fairly quick sketch, with smudges and redrawn parts, which he probably did from life. The impression of the animals paying attention to something just out of the picture is nicely shown, so that *The Adoration of the Magi* is already suggested by their pose.

2

THE
ART OF
SCIENCE

P art of Leonardo's study both as artist and scientist was of the human body: 'The painter who has acquired a knowledge of the nature of the sinews, muscles and tendons will know exactly in the movement of any limb how many and which of the sinews are the cause of it, and which muscle by its swelling is the cause of this sinew's contracting,' he wrote. He carried out a number of detailed dissections in order to be aware of the mechanics of the body.

By understanding how things were created, Leonardo believed it was possible for man to create in turn. He explored the four 'natural powers', 'weight and force, movement and percussion', and made acute observations about them. His interest in flight led him into a detailed examination of the flight of birds, and from there to his designs for flying machines.

Leonardo examined the flow of blood around the body and the flow of water across the earth. While in the service of Cesare Borgia, he proposed plans for draining the marshes at Piombino in the Romagna, and on his return to Florence drew maps of the lower course of the Arno.

Earlier in his career, Leonardo had commended himself to Lodovico Sforza, Duke of Milan as a military engineer and designer of many things, including breech-loading guns, slings, catapults, bridges and forts. He also proposed methods of tunnelling to destroy enemy defences, and ways of piercing hulls underwater to destroy enemy ships. Drawings of gears and ratchets, joints of various kinds and devices for raising water abound in Leonardo's notebooks. He identified the fundamental principles of mechanics and observed these laws in operation all around him in the natural world. By observing them he sought to create a language that could be applied in all circumstances to invent devices of immense variety: his own inventions were not only ingenious, they were also accompanied by beautiful drawings.

SKELETON HAND

These superb drawings of the bone structure of the hand are the first to be done with accuracy from observation. Leonardo shows the front, back and side view and his notes contain careful descriptions of how the hand is manipulated by the muscles and tendons. There is also the small sketch of the hand in a fist with descriptions about how this works. His terms are not exactly the same as the ones we use today, as he seems to have taken some from Arabic and some from Greek.

THE SKELETON

This magnificent series of drawings of the human skeleton, all from around 1510, shows Leonardo at his observational and analytical peak. His drawings have yet to be bettered by any modern anatomical artist, having not only accuracy but also some impression of the spatial depth of the bone structure and its texture. Leonardo intended to show the body in all aspects from infancy to old age.

The positions of the spine with its curves, the tilt of the sacrum, and how they relate to the statics of the erect posture are correct to the last detail. Nobody before Leonardo had drawn the human skeleton so accurately nor so beautifully; most of his predecessors' work was crude by comparison. His notes on this page speak of his interest in the 'part in man, which, as he grows fatter, never gains flesh . . . And among the parts which grow fat which is that which grows fattest'.

There are some anomalies in Leonardo's details of the ribcage because contemporary knowledge of the subject was not accurate, but it is noticeable that he often shows what is actually there when a more traditional illustration is wrong. Slight mistakes can be understood because of the difficulty of assembling a complete skeleton.

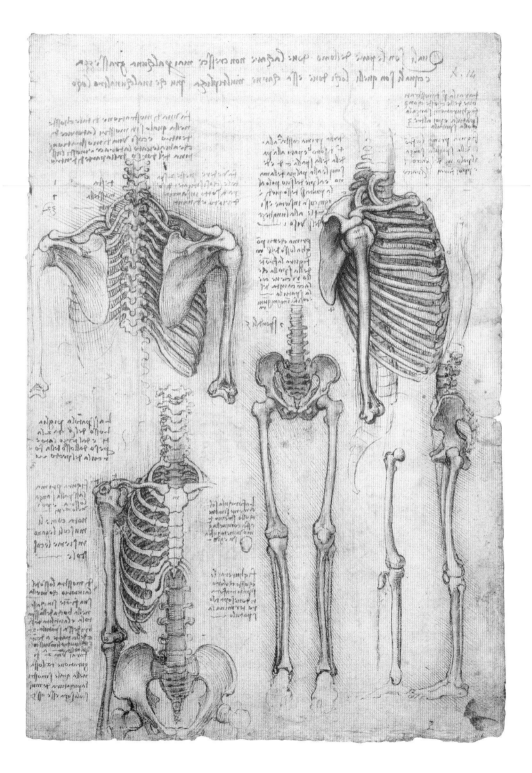

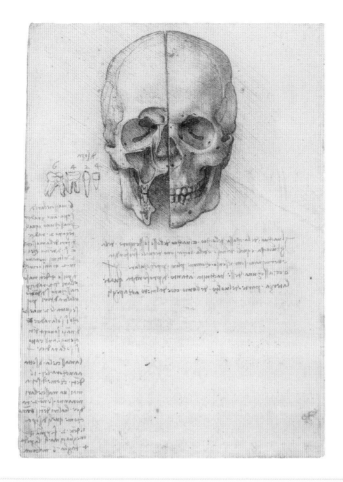

THE SKULL

This drawing of the human skull has been presented by Leonardo in such a way that the student can see what goes on under the superficial layer of bone structure as well as the whole shape. The skull, cut in two, has the frontal and maxillary sinuses, the nasal cavity and the roots of the teeth exposed on the side where the wall of the skull has been cut away. All the fissures in the skull visible from this angle are clearly and accurately shown.

As a drawing of the bone structure of the head, it has been universally admired for its accuracy and proportion. Alongside are careful drawings of teeth with their roots shown and numbered. In his notes Leonardo gives the number and position of all the teeth.

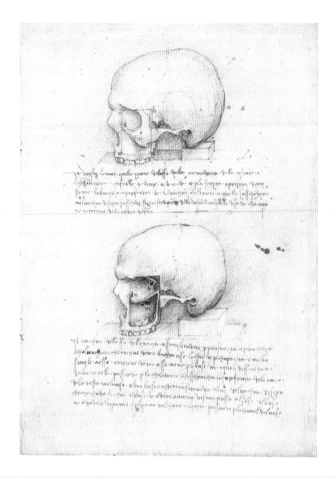

THE SKULL, SIDE VIEW

This second view of the skull is the only one Leonardo left which is complete, although the jawbone is not shown. He has placed a block under the occipital bone to keep the head level and show it as it would be in a live model. He has drawn all the sutures and cavities accurately and with a sense of their definition. Any art student who has had to draw the skull can appreciate the outstanding proportion of this drawing. Leonardo emphasizes hollows and edges where they need it, and softens the emphasis where the outline or edge is less definite.

In the lower example, the cheekbone has been removed to show the maxillary sinus; in his notes, Leonardo remarked that the cavity of the cheekbone resembles the eye cavity in size and depth.

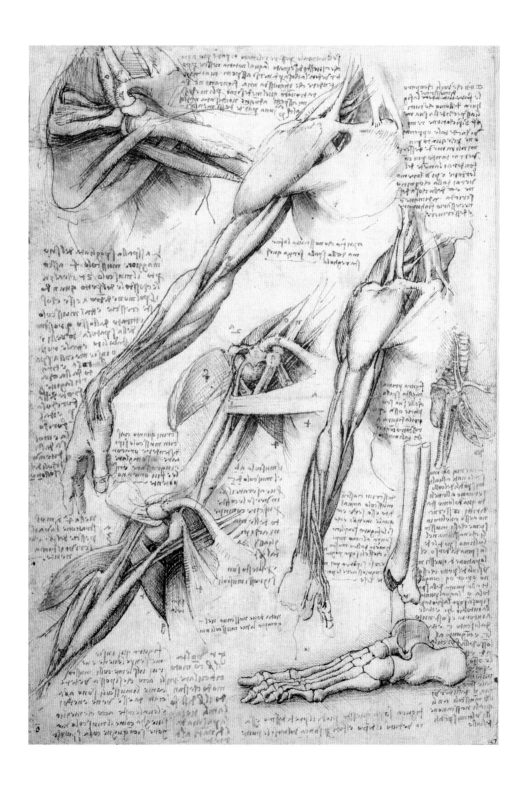

STUDY OF THE MUSCLES OF THE SHOULDER, ARMS AND BONES OF THE FOOT

Leonardo wrote of anatomical drawing, 'Every part will be drawn, using all means of demonstrations, from three different points of view; for when you have seen a limb from the front, with any muscles, sinews, or veins which take their rise from the opposite side, the same limb will be shown to you in a side view or from behind, exactly as if you had that same limb in your hand and were turning it from side to side until you had acquired a full comprehension of all you wished to know.' His notebooks contained measurements and drawings of each part of the body as he strove to establish '*universale misura del huomo*' – the universal measure of man. On this densely illustrated sheet dating from about 1510–11, his drawings using black chalk, pen and ink and wash show a deep dissection of the shoulder muscles, the muscles of the shoulder and right arm, a drawing of the respiratory muscles and a skeleton of a left foot. 'Observe how the position of the shoulder changes when the arm moves up and down, inwards and outwards, to the back and to the front, and also in circular movements and any others,' he advised himself in his notebook.

MUSCLES OF THE BACK

These drawings of the muscles of the back, from 1508–9, were probably made to show artists how to differentiate between the various shapes seen on the back of a figure. We can tell that the drawings are not of a living model because they follow the methods of Leonardo's drawings of his dissections of the body. In the drawings of the arm, for example, the divisions of the deltoid muscle have been exaggerated slightly and reflect Leonardo's methods of dissection: when muscles are put back together after dissection, the divisions remain rather more distinct than is normal.

This type of carefully outlined muscle structure was followed by Michelangelo in his drawings, which resulted in the wonderful realism and solidity of the great figures in the Sistine Chapel. Although Michelangelo could be critical of Leonardo's achievements, he must have been keenly aware of the enormous strides Leonardo had made in the depiction of the human body according to scientific knowledge rather than by observation only.

These drawings must have been of immense value to the artists of the time who had the chance to see them.

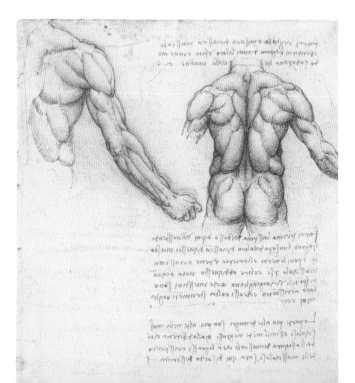

MUSCLES OF THE TORSO, SIDE VIEW

Again, this view of the muscles of the torso seen from the side is obviously informed by dissection, even though these are superficial muscles which show clearly under the surface of the skin. In the lower sketch Leonardo shows some of the deeper layer of muscles as they work under the superficial ones.

His handling of the tonal values in the drawings makes the most of the roundness of the muscles and gives a clear picture of the way the musculature lies across the ribcage and around the gut. His notes give an indication of how the muscles attach to the skeleton and to one another.

SHOULDERS AND HEAD OF AN ELDERLY MAN

The faces on this sheet of drawings, dated around 1511, are of an older man, and look like portraits made after death. Leonardo's interest in the shoulder area and the stringy quality of the neck would appear to have been overtaken by his interest in the cadaverous face, with its hooded eyes and sunken mouth and cheeks.

At this time, the dissection of corpses in order to gain knowledge of the structure of the body could be carried out only in places where the breath of Humanism had allowed permission for such scientific practices to take place. In many parts of Europe this activity would have been liable to prosecution by the Church, which was not always well disposed to scientific advance.

These drawings show perfectly the effect of old age on the flesh of the face, where the bone structure becomes pronounced as the flesh loses its vitality.

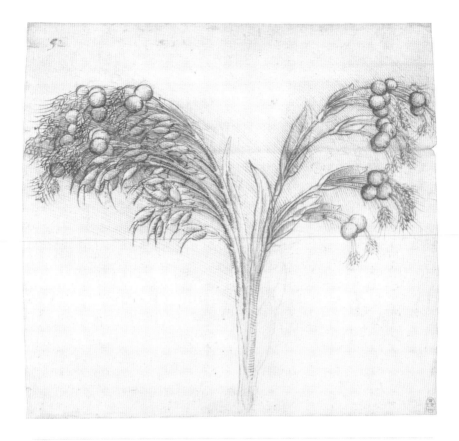

A LONG-STEMMED PLANT

This drawing in pen and ink over faint black chalk is of the perennial Job's Tears (*Coix lacryma-jobi*). It may be related to studies Leonardo made for the architectural work he intended for the new Medici palace in Florence around 1515. It particularly resembles his drawings of the archivolts made from intertwined branches which spring from tree-trunk columns. The elegant accuracy of the line drawing and the long, free strokes of shading give the plant a depth and naturalness that would not be possible to achieve with just a plain outline. No drawing of Leonardo's, however small or hurried, is ever without its artistic quality.

STUDIES OF WATER PASSING OBSTACLES

Earth as an organism similar to the human body was one of Leonardo's concepts both for his paintings and his scientific works. He studied the human anatomy and the structure of the earth in direct sequence, apprehending direct links between the two.

His advocacy of the superiority of painting over sculpture was supported by his knowledge that the painter could show transparency while the sculptor could not. Leonardo's preoccupations as a philosopher and scientist informed his artist's concern for showing effects realistically.

His depiction here of the effects of flowing water in all its transparency, with waves and bubbles, is keenly observed, hinting at the length of time he must have spent watching the way in which water moved. In some way his drawings are always scientific diagrams and his diagrams always works of art, and it is this ambiguity and inter-relatedness that sometimes makes it difficult to discern which is which.

In these studies of water flowing past obstacles, dated around 1507, the accuracy of the observation is matched by the artistic beauty of the water patterns. The water pouring into the pool, with the natural patterns of the forms of the swirling waves, is reminiscent of his drawings of plants, such as the Star of Bethlehem (see pp.30–1).

STUDY FOR THE CUPOLA OF MILAN CATHEDRAL

While he was in the service of Ludovic Sforza in Milan in
the 1480s, Leonardo took part in a competition to design the
tiberio of Milan Cathedral – the first construction project he had
engaged in. The building of the cathedral had begun in 1386,
at the height of European enthusiasm for the Gothic style for
religious buildings, and by 1402 it was nearly half completed.
There followed several decades of little activity until the 1480s,
when ambitious improvements to the design were initiated,
and Leonardo was consulted; he was very familiar with the
unfinished building, as he lived close to it. He made this study
for the cupola in black pencil, pen and ink. The drawing is
pierced in preparation for transferring or duplicating, but was
never used since the work of other architects was preferred.
Nevertheless, the experience prompted Leonardo to embark
on what became a wide-ranging exploration of architectural
designs.

173

3

THE
HUMAN
CONDITION

L eonardo was certain that below the surface of the physical form was the soul, and it was in portraying this inner world that he excelled. Leonardo's work, perhaps more than that of any other painter, portrays the inner spirit of his subjects with immense depth and sensitivity.

In the notes he prepared for a proposed book, *The Artist's Course of Study* – in which he examines in detail the various skills required of an artist – he discusses the importance of proportion in the body. His famous drawing of a man with outstretched arms and feet enclosed in a square and a circle, the *Vitruvian Man*, shows how the proportions of the human body relate to fundamental geometric principles. The notion that man carried in the proportions of his body a universal template which in the microcosmic world was reflected the geometry that governed the whole of creation, fascinated Leonardo: 'Man is the measure of all things,' he wrote.

Leonardo spoke in detail about the importance of creating harmonious concord. He taught his students the importance of knowing the human body from the inside out, of the awareness of its structure and the universal laws that governed it. Behind this awareness of the body as a harmonious and exquisitely designed machine was an understanding of the body as the outer expression of the emotional world inside. He wrote, 'A good painter has two chief objects to paint, man and the intention of his soul; the former is easy, the latter hard, because he has to represent it by the attitudes and movements of the limbs . . . in painting . . . the movements of each figure express its mental state, such as desire, scorn, anger, pity and the like.'

Harmony, proportion, unity, divinity: these were the qualities that informed his work.

STUDY OF ARMS AND HANDS

These hands, dated around 1474, in silverpoint on prepared paper heightened with white, were possibly for a portrait that has since been lost, called the *Lady of Lichtenstein* portrait. These elegant, loosely held hands probably represent the most exquisite drawing of hands in the history of art. Every detail of the long fingers and the beautifully modulated shading produces a convincing effect of reality so that one can almost know the person from her hands. The foreshortened left forearm is swiftly and simply drawn. One can easily visualize these arms moving in conjunction with the body. This is an exercise in how to draw human hands to the peak of human skill.

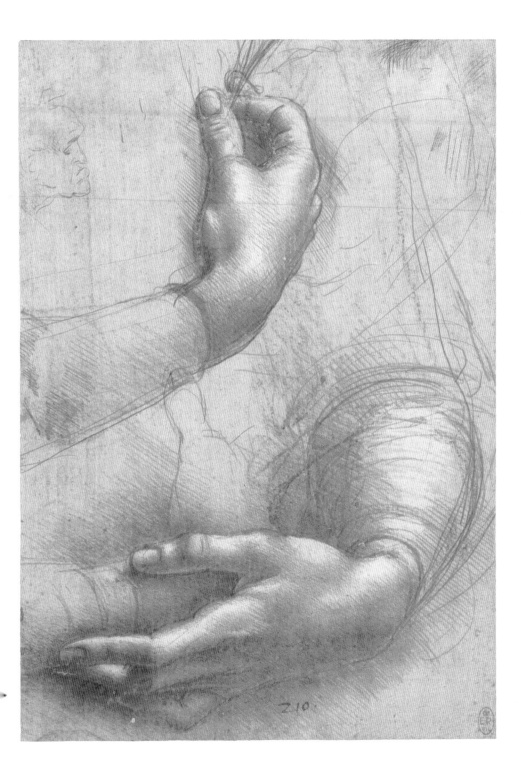

210.

THE BABY IN THE WOMB

This extraordinary drawing of an unborn baby in the womb, from around 1510–12, is derived partly from Leonardo's knowledge and partly from hypothesis. The covering of the foetus is based on what he had observed and does not strictly correspond with what occurs in the human womb. Nevertheless, his vision of the shape of the child curled up in the uterus is realistic and well-drawn. His notes also shed light on the knowledge of the time: for example, although he knew the foetus did not breathe as such, he also believed that the heartbeat he could hear was only that of the mother, and he shared the assumption that the soul of the foetus was indistinguishable from that of the mother. The rest of the details on this sheet show other versions of the details of the foetus; at the bottom is a small diagram and notes on the binocular vision of the eyes.

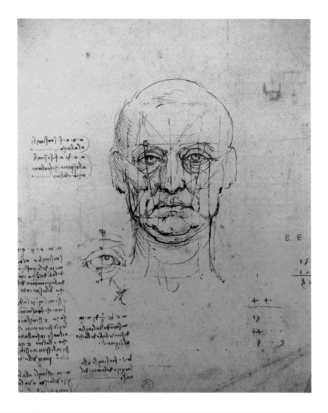

STUDY OF THE PROPORTIONS OF THE FACE AND THE EYES

Leonardo's first detailed anatomical drawings were of the head, where he attempted to establish the location of the *senso commune*, the supposed meeting place of the senses and the soul. Dating from about 1489–1490, this drawing is among the many studies of the human form that he made at the time, including a number of profile views of the head in which he addressed its proportions in detail. He described vision as the most important and best sense and included here a separate drawing of the proportions of the eye; during the period from about 1487 to 1493, many of his dissections were concerned with the sensory nervous system, especially relating to vision. While he added copious notes here, as in many of his drawings, one comment on an anatomical study stated his view that drawing imparts knowledge in a way that is 'impossible for ancient or modern writers without an infinitely tedious example and confused prolixity of writing and time'.

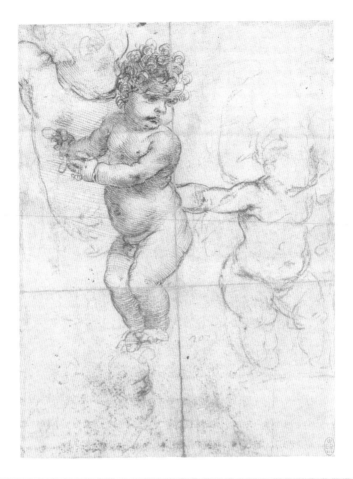

YOUNG CHILD

This beautiful drawing of a *putto*, or child, naked and perfect in its chubby form, shows the bracelet-like creases at the wrists, the curly vitality of the hair, the curiosity in the face expressing attention to something of interest, the soft dimpled limbs and, in the handling of the tone, the rounded shape of any well-fed child. It is a good example of Leonardo's ability to show what many had shown, but with his own added precision and reality. Although the drawing, dated around 1505–6, could be recognized as decorative, it is more than just an idea of a child; it is an image of all children of this age, with its innocent vigour and its vulnerable softness of form. Leonardo drew many such figures and they all give an accurate impression of a baby's shape and its actions.

PORTRAIT OF A YOUNG WOMAN IN PROFILE

This pure profile of a young woman, drawn with great economy, is typical of the style of early Renaissance profile portraits, particularly those of women of this age. Leonardo has carefully shown enough of the hairstyle and bust to give a clear idea of the final effect, but concentrated most of his efforts on the outline of the features and just a little section of the hair nearest the face. The well-modulated tonal marks give a good impression of the fullness of the cheeks and neck and help to show the veil over the back of the head. Could this have been intended for a portrait or was it just a sketch to define a face he wanted for a religious painting? Whatever the reason for it, the very restrained expression suggests that it is likely to have been a portrait drawn directly from life. It dates from between 1485 and 1490.

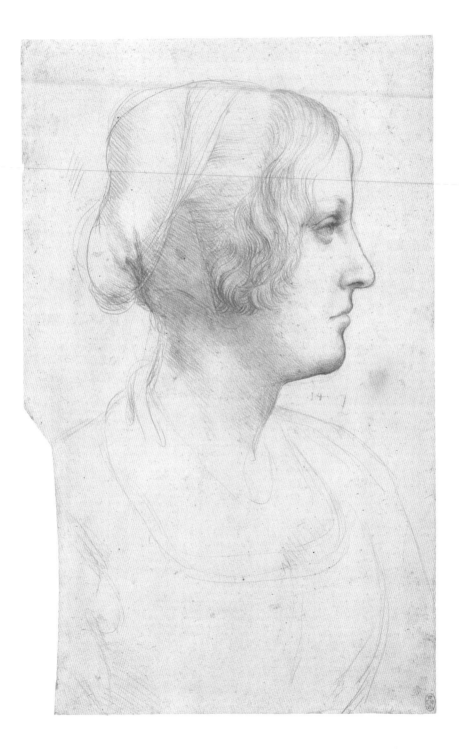

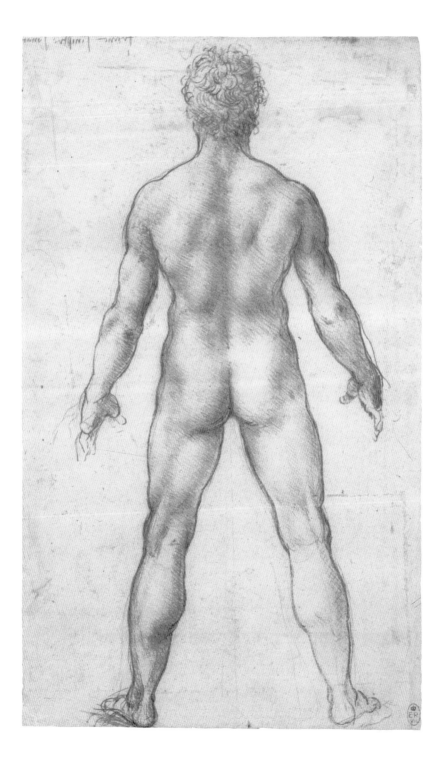

NUDE BACK VIEW OF A MAN

This drawing in red chalk of the back view of a naked young man is arguably one of the most subtle and understated life drawings in existence. Dating from around 1505, it is only about 28cm (11in) high, and was probably drawn sight-size. It is a comprehensive study of the musculature under the skin, with just the right amount of emphasis that makes most other life drawings look either overdrawn and exaggerated or flimsy and undefined. Every ripple of the muscles is indicated in the most economical way by the accomplished touches of tonal hatching, which allow the eye to fill out the form. The muscles of the back are particularly difficult to draw clearly without over-emphasis, but Leonardo succeeds with the lightest touch, exhibiting the results of his exhaustive research into the human body. The flowing outline is well defined and yet does not hinder the movement of the eye, allowing the viewer to imagine the form continuing round to the front of the figure. The hands and one leg are less defined than the rest of the body, but this does not detract from the main effect of the realistic look of this youthful male figure. The underlying skeletal structure is visibly in place, indicated by the areas where the bones come close to the surface. It is a magnificent life study.

HEAD OF ST ANNE

The *Head of St Anne* is a preliminary drawing for the painting *The Virgin and Child and St Anne*, which can be seen in the Louvre in Paris. Leonardo produced this in about 1509–10. One can see the transition from the beautiful freshness of the drawing of a tender human face to the more idealized version that is produced in the final painting. The mysterious smile is wistful and maternal as the saint looks down at her daughter and grandson; the depiction is emphatically that of a mother and Leonardo has caught the tenderness implicit in her gaze. The subtle handling of the *sfumato* technique of shading appears natural and convinces the viewer of the real presence of the woman.

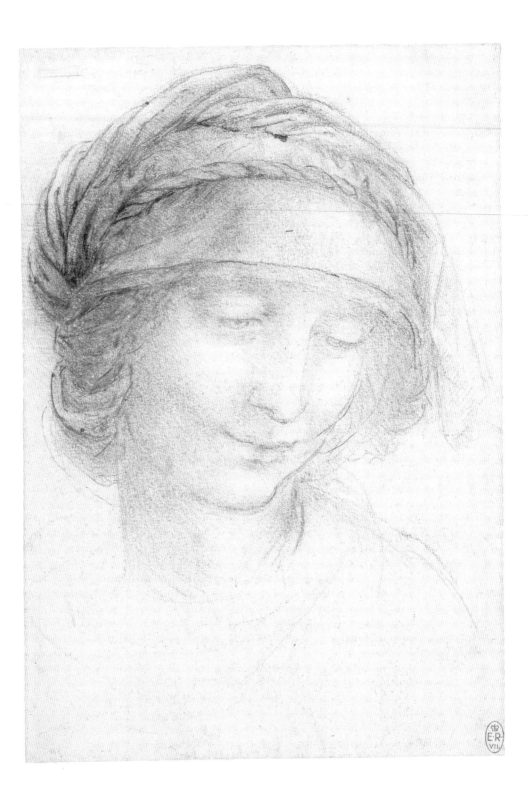

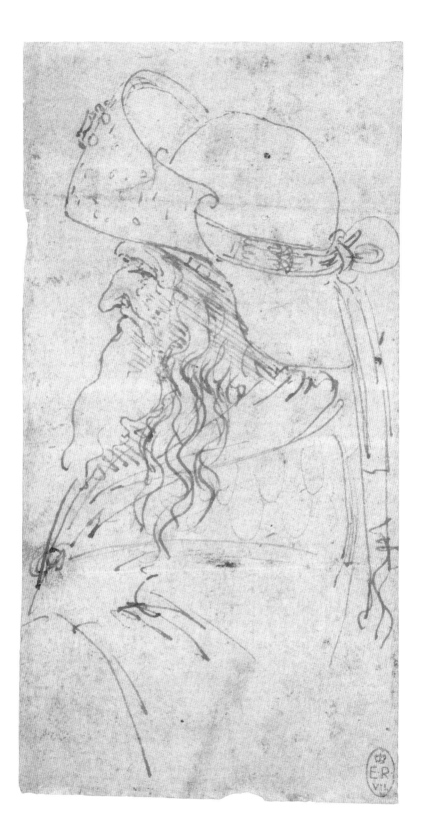

HEAD OF AN ELDERLY MAN IN A HAT

This remarkable old greybeard, with a large-brimmed pilgrim's hat, is beautifully caught with Leonardo's flowing lines. One wonders whether he was aware of being drawn; it does not look as though the subject was posed, because then the drawing would have been more deliberate, with greater detail. It looks instead like an instant sketch during a ceremony or similar event where citizens are gathered together. The obvious speed of the drawing is evident in the confident, loosely drawn lines, all rendered with the minimum of hesitation or deliberation. The face somewhat resembles Leonardo's own face in old age, which is included in this section overleaf. Perhaps this subject was considered for a small part in one of Leonardo's bigger paintings, or it could be just a spontaneous sketch made for the artist's own amusement.

SELF-PORTRAIT OF LEONARDO DA VINCI IN OLDER AGE

This dramatic elderly face with its balding head, long beard and side hair gives a compelling insight into the qualities evident in Leonardo's work. The penetrating gaze tells of his observational powers and his confidence in the powers of his intellect to interpret accurately what he sees. There is also a hint of warmth and humanity in the eyes looking out from under the ledge of the jutting eyebrows. The long Florentine nose and the firm down-turned mouth give some idea of his scepticism and refusal to take as truth that which appeared on the surface. The manifest intelligence in the face underlines the great inventive powers which meant Leonardo could foresee inventions that technically were not able to be constructed until hundreds of years later, when technology finally caught up with the brilliance of his investigations.

Finally, the technique of the drawing shows Leonardo's ability to concentrate on the essential qualities first, and indicate the rest precisely but economically. The features reveal the character behind the face by using emphasis effectively.

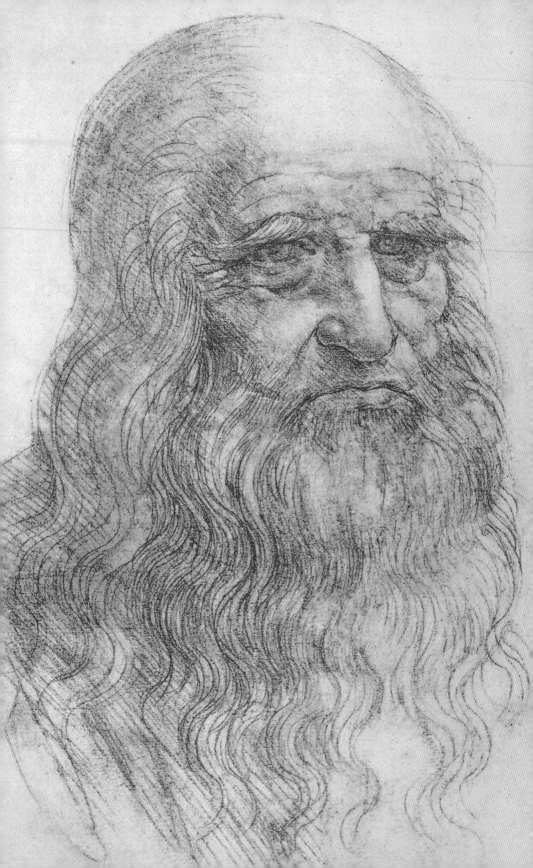

HEAD OF A WOMAN

This Madonna-like head of a woman, from around 1510–1515, has
resonances with Leonardo's drawings of St Anne and the Virgin
in the marvellous *Burlington House Cartoon* in the National Gallery,
London. Of course, he would have been called upon to portray the
Virgin Mary often, but it appears that in drawings like these he is
trying to develop a type of face that will show beauty, grace and a
certain power of wisdom through suffering – not the mystery of the
Mona Lisa with her alluring smile, but a more devout face with an
inner poise and calm that produces an effect of holiness and quietude.

The gently inclined head, the headdress (often associated with
the Madonna), the lowered eyes and the gentle, calm smile of a
mother looking at her child epitomize the universal maternal ideal.

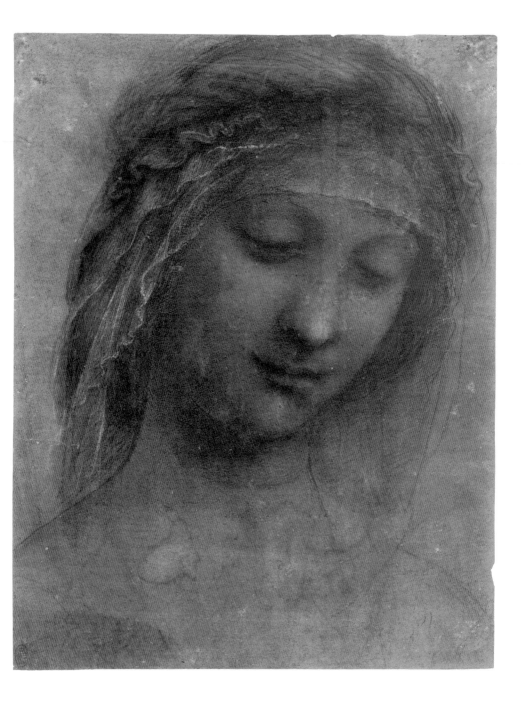

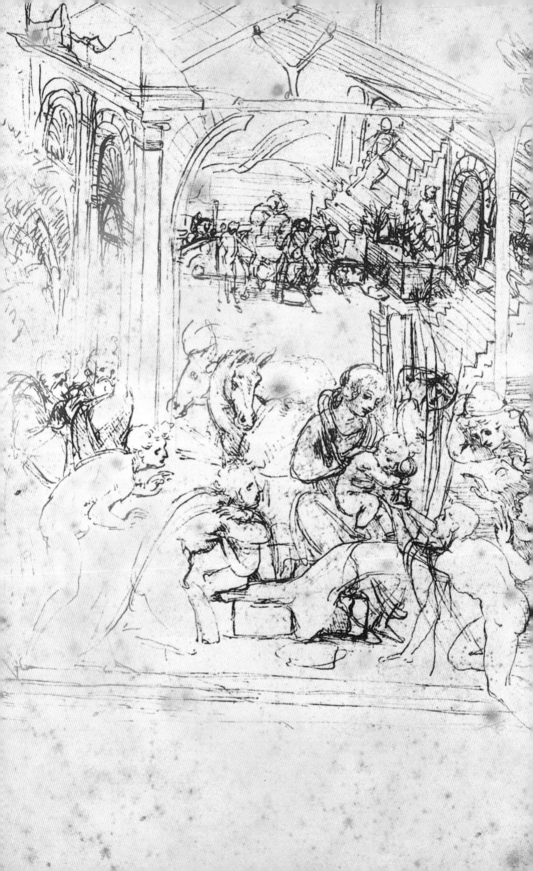

SKETCH FOR THE ADORATION OF THE MAGI

This sketch shows the central part of the great *Adoration of the Magi*, which never progressed past the underpainting form. In the background is shown the beginnings of the architectural staircases which in the final piece would be built on the opposite side of the composition, taking the main part of the story out from under the stable roof. The frame of the stable was rejected for the final design, but here resembles Piero della Francesca's version of the stable in his depiction of the event. Whether Leonardo used the Piero idea knowingly or not is uncertain, but the depiction of a small, ruined stable was traditional in paintings of the Nativity.

There are figures hovering on the stairs and in and out of the arches, which in the later version became further augmented by horsemen caracoling at the bottom of the staircases. A complex system of arches penetrates through and under the stairs, with various groups of people and animals gathered in the spaces. The deferential figures of the worshippers clustered around the Virgin and Child form a frame; in the more finished work this is even more clearly stated.

The drawing is hastily executed in fluid lines with some energetic toning and overlaying in order to correct first thoughts.

4

EXTREME EXPRESSION

According to Vasari, Leonardo often drew the people he saw in the streets and taverns from life, in a notebook he always carried at his waist. It was also claimed that he followed those who particularly interested him in order to memorize their characteristics. He recommended to his pupils that 'when you have well learnt perspective and have fixed in your memory all the parts and forms of objects, you should go about and often as you go for walks observe and consider the circumstances and behaviour of men as they talk and quarrel, or laugh or come to blows with one another; and the actions of the men themselves and of the bystanders, who intervene or look on'.

There is no doubt that Leonardo had a feeling for the rude comedy of life. Here is one of his ribald tales of nature, full of human character: 'A woman washing clothes had very red feet from the cold. A priest who was passing nearby asked her where the redness came from. In answer the woman replied that this result came about because she had a fire "down below". Then the priest took in his hand that member which made of him more a priest than a nun, and coming close with sweet caressing tones begged her to be so kind as to light that candle.'

In a more serious vein, on the composition of a group of men listening to an orator, Leonardo wrote: 'Make some of the old men in astonishment at what they hear, with corners of their mouths pulled down, drawing back the cheeks in many furrows with their eyebrows raised where they meet, making many wrinkles on their foreheads.'

He was concerned as much with human absurdity as he was with mankind at its most divine, and his perceptive understanding of the human condition in all its variety is to be found in his work. His awareness of psychology is evident as, in a few deft strokes, he captures and portrays the inner workings of the mind. The nature of humanity, from the most elevated of souls to those characters found in the odd corners of life, was Leonardo's concern.

GROTESQUE HEADS

This page of grotesque heads, dated around 1490, is rather like a catalogue of the distortions possible in the human face. The central figure is not exceptionally unusual but his flapping, loose cheeks give a curious look to his head. The three heads at the top are far from attractive, while the lower two heads, which look as if age has taken away their dignity and left them with only the worst features of senility, look slightly malevolent. Leonardo was obviously fascinated with these exaggerated features and seemed to be testing how far he could take the distortion without straying too far from reality.

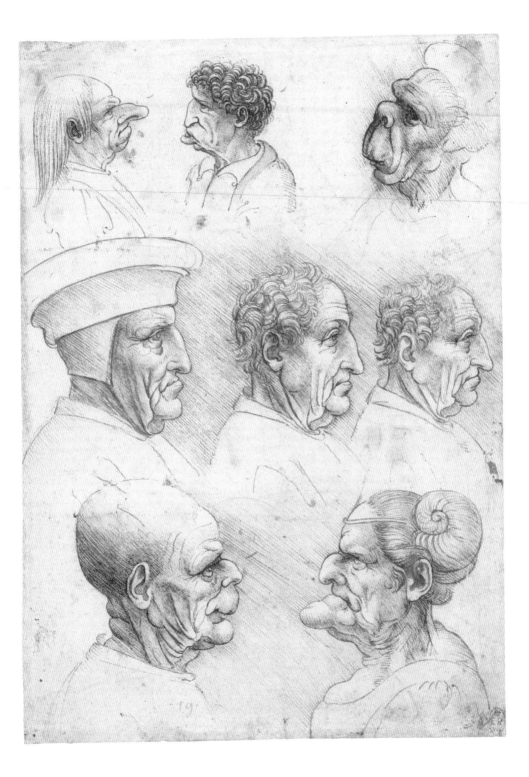

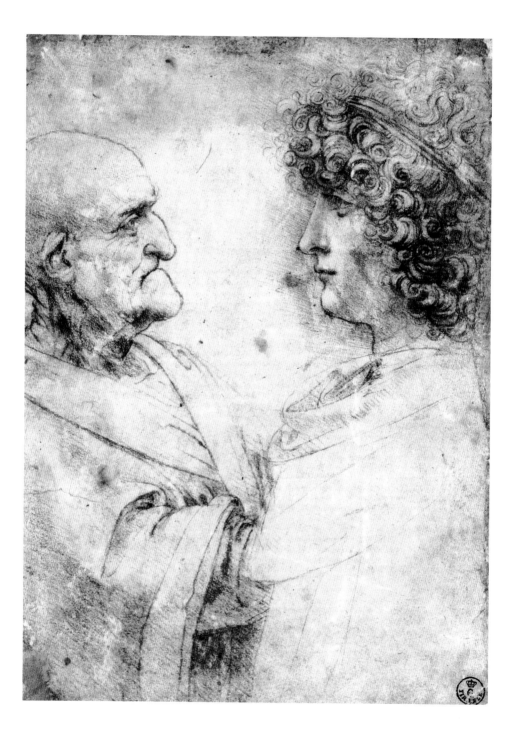

AN OLD MAN AND A YOUTH FACING EACH OTHER

From an early age, Leonardo made many drawings of males of two types: adolescent, with well-formed, handsome features, and an older man with a pronounced nose and heavy chin. This red chalk drawing, dated c.1500–1505, contrasts the smooth skin, straight nose and luxuriant curls of the youth with the depredations of age on his older companion. It is thought that the youth may be Giovanni Giacomo di Pietro Caprotti, nicknamed Salai (Little Devil), who joined Leonardo's household at the age of ten and became a studio model and general errand boy; Leonardo also trained him as an artist. According to the painter, writer and historian Giorgio Vasari, Salai 'had beautiful hair, curled and ringletted, in which Leonardo delighted' and the heavy-lidded eyes that Leonardo favoured. Salai remained a member of Leonardo's establishment for 25 years, possibly as his lover. The older man facing him here, rather than being a self-portrait, acts to emphasize the youth and beauty of the boy.

BUST OF WARRIOR (IN ANTIQUE ARMOUR)

This beautiful, elaborate drawing of a grim-looking warrior in a highly decorative helmet and armour is a real tour de force from the young Leonardo; the invention and decorative work interleaved around the helmet are of the highest quality. It has some resemblance to the mighty sculpture of the great Venetian *condottiere* Colleoni, but the armour is so fantastic that it would have been impossible to make, or fight in. However, the power of the face is obviously based on a real portrait, with the jutting lower lip and the unequivocal stare conveying the quality of a mature warrior.

This is an early work, made when Leonardo was probably still in Verrocchio's workshop as a young assistant. The drawing, in silverpoint, has a softness of tone that graphite lacks.

The subject matter would have been a favourite one at this time because art workshops needed to produce model drawings of this kind that could then be copied into paintings, both on fresco and panel. The bravura of this soldier has all the Renaissance swagger that the Italian warrior might show when displayed in his full battle armour. This type of figure was much used by Verrocchio, but Leonardo brings it right up to date so there is no doubt that although the subject is an 'antique type' of warrior, he looks very much alive and of the moment. Again, Leonardo's genius takes this image out of the run of examples used for repeated commissions in Florentine workshops at the time, and introduces a more closely observed, realistic style.

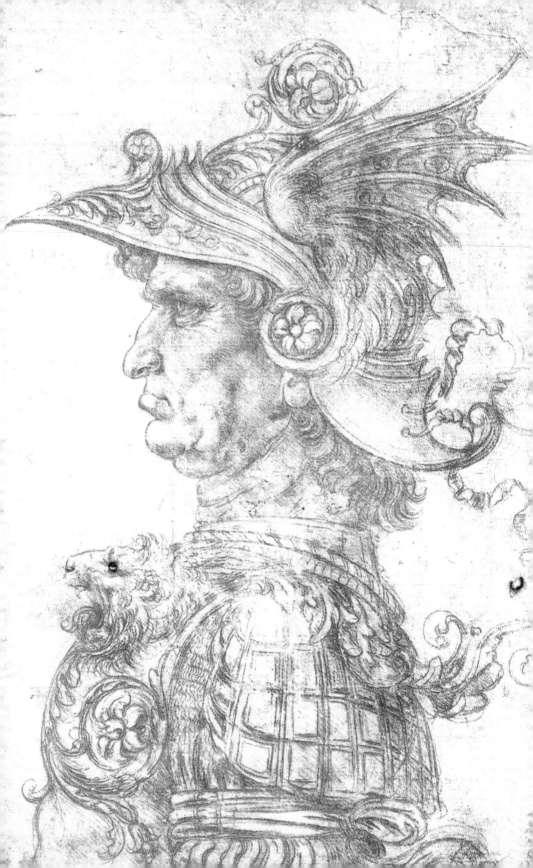

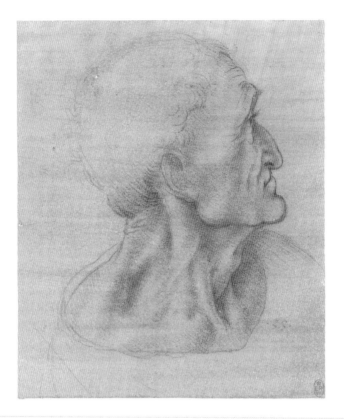

HEAD OF JUDAS

This sombre portrait from around 1495 or later of Christ's apostle Judas shows a man with good intentions who, for egotistical reasons, decided to betray his friend and master. The look on the face is uneasy. The strain in the expression shows disbelief and a grim determination to carry out a disloyal act as if it were justifiable.

Leonardo's drawings of the apostles around the table in the great mural *The Last Supper* at Santa Maria Delle Grazie are among the most powerfully emotive faces ever used for this theme. Many lesser artists of the period could not achieve Leonardo's quality of realism and often descended into caricature. But here there is no doubt about the dark thoughts in this man's head. They show, subtly, on his upturned face.

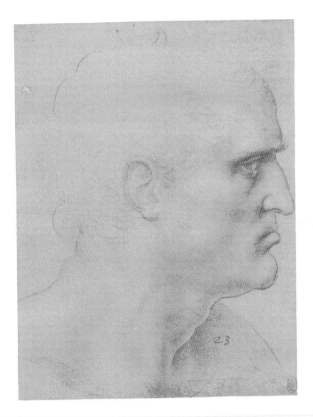

HEAD OF APOSTLE – ST BARTHOLOMEW

In this portrait of another apostle, from around 1495, St Bartholomew is drawn in red chalk on prepared paper. The stern visage is full of consternation at Jesus's words – that one of the Twelve will betray Him – but calm and steady, reinforced by the physical form of the head and neck. Here is a strong, solid-looking head, intelligent, perhaps intellectual, but powerful and charged with determination. Although troubled, he knows he is not the traitor.

The modelling of the powerful neck and jaw and the overhanging brow is beautifully modulated to suggest the tension of the muscles under the skin. The intensity of the tone around the eye sockets and along the line of the profile produces an effect of brooding power. Everything in Leonardo's drawings of faces, including the type of hair, the subtle shaping of the features, and the positioning of one feature against another conveys a definite type of physiognomy familiar in real life. The characterization of his figures is masterly.

HEAD OF APOSTLE – ST JAMES THE GREAT

Another apostle's head of the same date, also for the mural of *The Last Supper*, is this time of the leading teacher-apostle, St James the Great. This drawing in red chalk and pen and ink displays the reaction of disbelief and shock in the most sensitive and perceptive of Christ's disciples. The recoiling of the body and the open mouth are reminiscent of the reaction of Mary shown in many pictures of the Annunciation. In the final painting, St James' arms are outstretched in a gesture of surprise and openness, as though caught in a cry of, 'How can this be?'

In this vigorous line drawing, the wiry pen line and the soft chalk produce an effect of youth, refined grace and beauty. The way Leonardo has shadowed the eyes as they look upwards from the tilted head makes the power of the gesture ever more telling. You can almost hear St James's gasp of horror at the suggestion of betrayal.

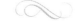

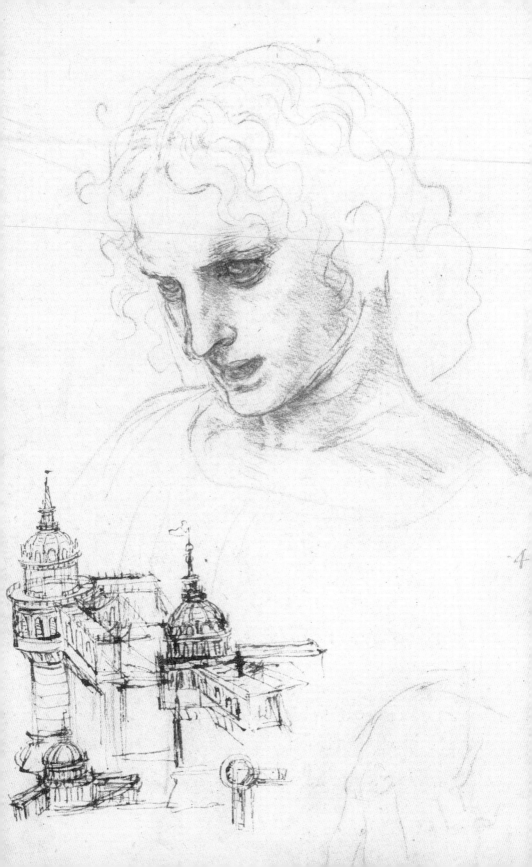

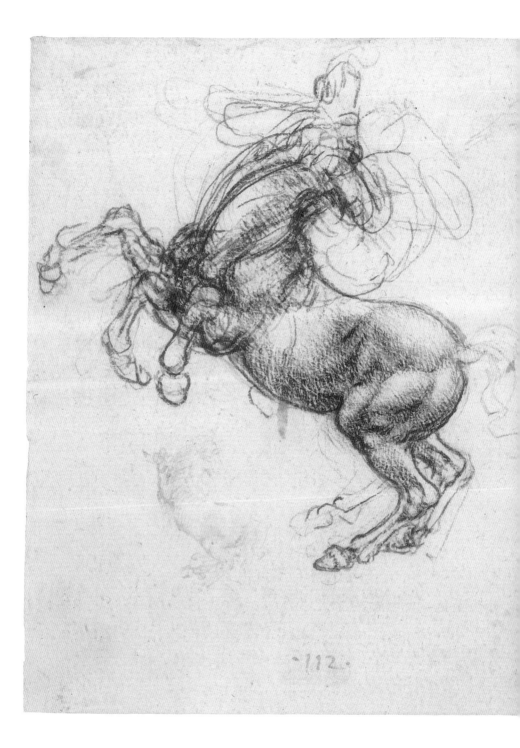

·112·

REARING HORSE

This red chalk drawing of great vigour and activity is dated to c.1503–1504. Here the expression is all equine, with the magnificent steed lifting its forelegs, rolling back or turning its head and tensing its hindquarters as it almost throws the barely drawn figure outlined faintly on its back. This drawing is probably one of Leonardo's sketches for *The Battle of Anghiari*, although he did many similar ones for monumental statue projects.

The restless movement of the horse is emphasized by the way Leonardo has left in some doubt how he wanted the horse's head and neck to be drawn. There are two distinct variations: one with the head thrown upwards and back in an effort to release itself from its restraining harness, and the other where the head is twisted to the left as though the horse is in the power of the rider's grip, trying to settle its front legs back to the ground. Either would work well, and it is as though Leonardo is happy to leave both versions of the drawing before he makes up his mind. The extra front and back legs also give indications of how the drawing could be altered to either possible position without losing the quality of the moment. It is part of Leonardo's genius that we accept all the variant poses within the one pose and interpret its meaning, rather like a photograph with a timed image showing different parts of the movement in blurred sequence.

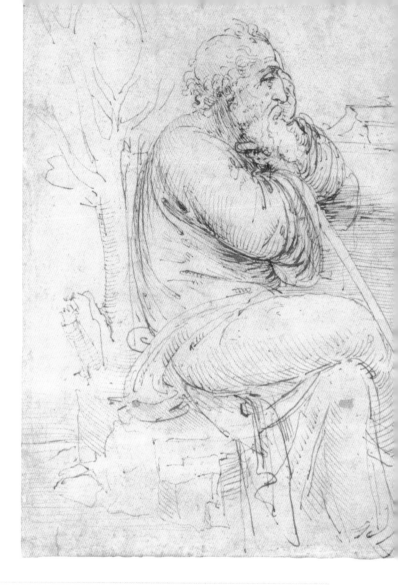

SELF-PORTRAIT IN OLD AGE (DETAIL)

Believed to be a self-portrait dating from around 1513, this drawing portrays an expression of age that has given up striving and expectation. The head held in the hand as the seated figure leans on his staff, engrossed in thought or meditation, has a serious and cryptic expression that suggests a lack of hope for the future of mankind. The down-turned mouth and melancholy eyes seem to regard the future without much enthusiasm. Whether or not this is a self-portrait, the feelings of the figure are clear.

The technique of the drawing is confidently and crisply executed in pen and ink with light touches of tonal hatching, which give enough shadow without making the detail too heavy. This looks like a work from the imagination; whenever Leonardo drew a man of his own age the physiognomy tended to be similar to his own, and not drawn from life. All artists tend to draw themselves in their characters, and more so when drawing from memory.

BATTLE BETWEEN HORSEMAN AND DRAGON

This energetic drawing in pen, ink and wash, from around 1481, is only about 14cm (5½in) high and obviously drawn with speed. However, everything in the picture is as clear as can be; the muscular hindquarters of the horse, its swinging head and neck, the shouting energy of the rider and the dragon's voracious jaws and grappling claws.

The dragon's wings and tail are flicked in without any detail, but with enough definition to show what is going on. This sort of drawing, associated with the great unfinished work *The Adoration of the Magi*, is a strange piece of symbolism to place in the background of such a religious setting. There are many opinions as to why this sort of activity could fit into the great work, but there is evidence of Leonardo's continued fascination with this subject in his great projects for equine sculptures and *The Battle of Anghiari* series. Thus, this drawing is an early version of what was to become a continuing theme in his work.

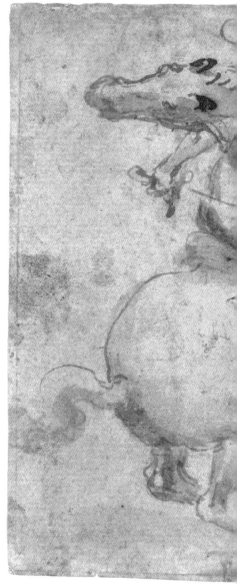

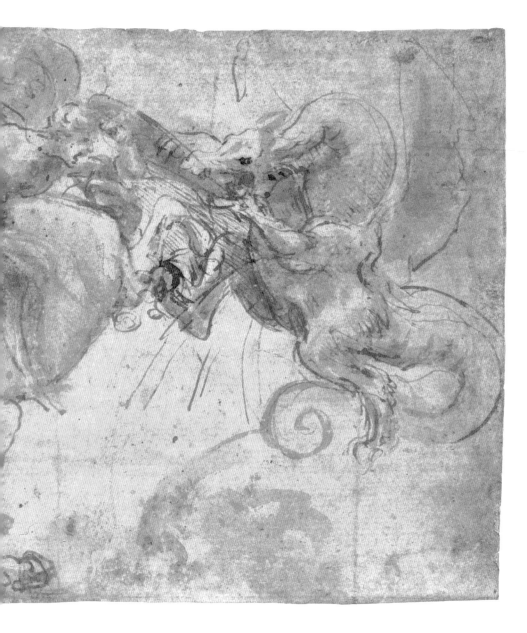

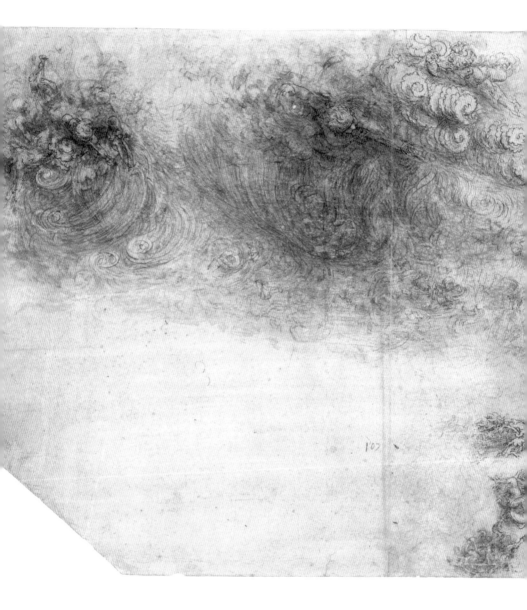

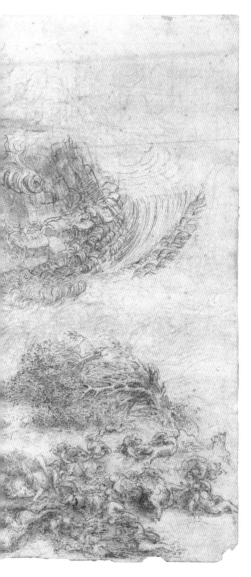

HURRICANE

This pen-and-ink over charcoal drawing of a great storm or hurricane, dated from around 1515, has clouds sweeping across a mountainous landscape and swirling waters, great waves and floods. The suggestion is that everything will be swept away by the power of nature let loose across the landscape. In the bottom corner there is a desperate struggle between horsemen who are also affected by the storm which has torn down the trees on the edge of an expanse of water. It is as though the horsemen are struggling both against one another and the turbulent wind.

The fascinating details of this drawing include Leonardo's favourite subject of water patterns, which he observed and used in his more imaginative projects. The repeated curls and undulations of water and cloud here are helped along by the gesture of aerial figures, the gods of wind and tumult letting forth the elements. The drawing of the broken trees lying on the ground is detailed enough to show their structure and the way in which they have been shattered. Small figures cling to the trees, which are bending with the blast. Leonardo drew many variations of this type of apocalyptic scene.

5

CONFLICT

In his *Thoughts on Art and Life,* Leonardo describes at length how best to represent a battle: 'The air must be full of arrows falling in every direction: some flying upwards, some falling, some on the level plane; and smoke should trail after the flight of the cannon-balls. The foremost figures should have their hair and eyebrows clotted with dust; dust must be on every flat portion they offer capable of retaining it. . . . Put all sorts of arms between the feet of the combatant, such as broken shields, lances and broken swords.'

He goes on to suggest a creative process in which the artist sketches out his ideas until he has in mind the movements of the figures drawn in such a way that 'the mental motions of the protagonists are clearly visible.'

Leonardo wrote of the cruelty of men, 'their desire to deal out death, affliction, labour, terror . . . Nothing shall remain on the earth, or under the earth, or the waters that shall not be pursued, disturbed or spoiled'.

Ironically, these are the words of one of the foremost military engineers of the time, for in Leonardo's notebooks, alongside designs for great battle scenes which are both heroic and terrible, are many beautiful sketches and more fully realized technical drawings covering many aspects of military engineering.

In his successful application for employment in the service of Duke Lodovico Sforza, Leonardo described his abilities to make 'cannon, mortars and light ordnance, catapults, mangonels, trabocchi and other engines of wonderful efficacy and general use'. He also mentioned his abilities as a bridge-builder and mining engineer. Leonardo lived up to his claims, adding the design of forts and defence systems.

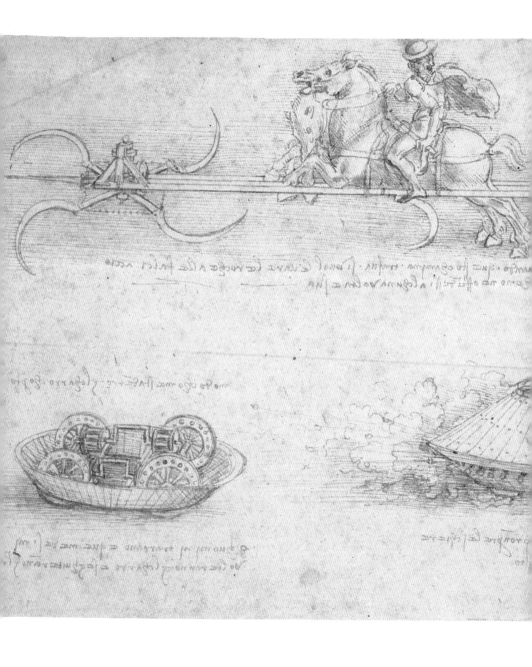

SCYTHED CHARIOT AND ARMOURED VEHICLE

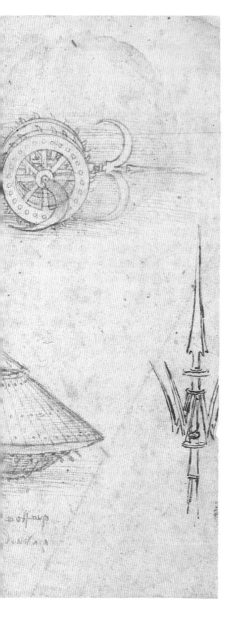

This is one of Leonardo's most famous war machine drawings, in pen and ink and wash, which foresees the advent of the tank or armoured car. The scythed chariot is reminiscent of Boadicea and her chariots, but vastly more sophisticated. The four whirling scythes in front of the horses would render infantry ineffective to attack or stop the chariot. The wheels and scythes behind would wreak havoc and protect the rider from attack in the rear. It was quite a deadly war machine, but was probably never made.

The tank is even more fascinating. The sloping armour was to prevent missiles from damaging the machine. As there was room for eight men underneath to drive it and fire through the portholes, it would have been difficult to stop and almost impossible to attack the crew. It was designed to break up enemy formations, which no doubt it would have succeeded in doing. Military interest in this particular form of armoured car did not revive until World War I. Once again Leonardo puts new ideas together that demonstrate his understanding of how to harness knowledge for practical purposes.

DRAWINGS OF FORTIFICATIONS, MANUSCRIPT B

From the late 15th century onwards, Leonardo made numerous
studies relating to warfare, including fortifications, weapons for naval
battles, siege engines to hurl projectiles at stone walls, tanks and even
a submarine that could pierce the hulls of ships. One of his sources
of ideas was *De Re Militari* (*On the Military Arts*) a military treatise by
Roberto Valturio that was completed in about 1460 and distributed
to several European rulers, including Francesco Sforza, fourth duke
of Milan; it is known that Leonardo had access to it and found some
of his inspiration for military technology there. To the left of the
building in this drawing is a helical staircase which, unlike a spiral
staircase, has no central column. Leonardo designed it as a double
helix, which meant that soldiers descending the staircase would
be able to avoid invaders ascending it. But in spite of his prolific
inventions and investigations of warfare, he referred to a battle as
pazzia bestialissima (the most bestial madness).

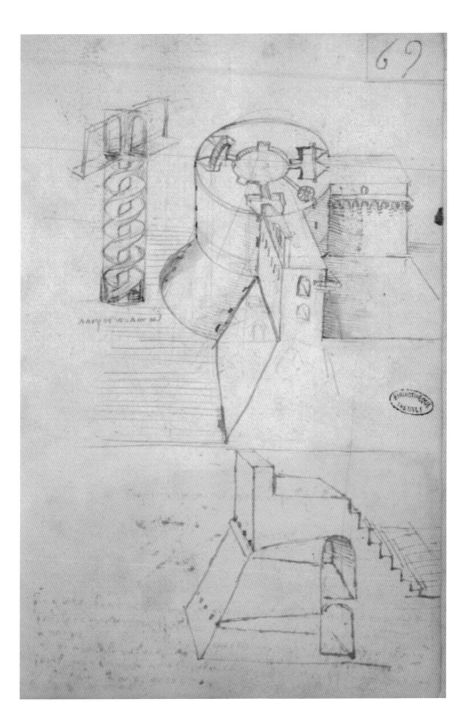

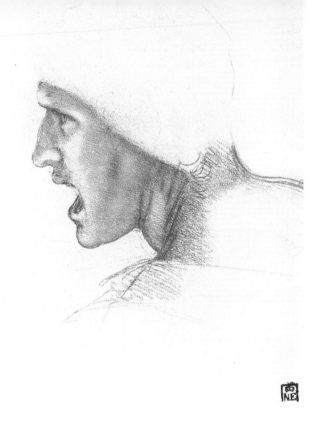

HEAD OF YOUNG WARRIOR, SHOUTING

This young warrior comes from the drawings associated with *The Battle of Anghiari*. The highly finished face is carefully drawn and must be from a life model. Leonardo has shown the smooth curve of the cheek as it is stretched by the open jaw, gradating the tone from the depth of the shadow by the ear and on the jawline to the relatively light surface of the front of the cheek near the nose and the lower eyelid. The beautifully controlled sanguine tone, drawn with light, angled strokes repeated so close together that they become one tone, is evidence of his control of his *sfumato* technique. The barely drawn edges of the brow and nose contrast with the strongly defined lines of the mouth and chin. The eye glares out from the shadowed eye socket and the creases in the turned column of the neck are deeply etched. As he left out the top of the head except for a bare outline, Leonardo was probably concerned here with a facial type for one of the main warriors in *The Battle of Anghiari*. It is one of his more highly finished drawings for this great battle piece.

HORSEMEN GALLOPING

These galloping horses, beautifully observed but roughly sketched in chalk in about 1503–1504, stretch across the paper and must have been drawn while Leonardo was watching horses being put through their paces. He has achieved the two stages of the gallop, when the legs stretch out and when they curl up under the horse's body before the next bound. They show how Leonardo would make study after study in order to get the right effect in his compositions. The soft, loose lines show the practised hand of the master of the instant sketch.

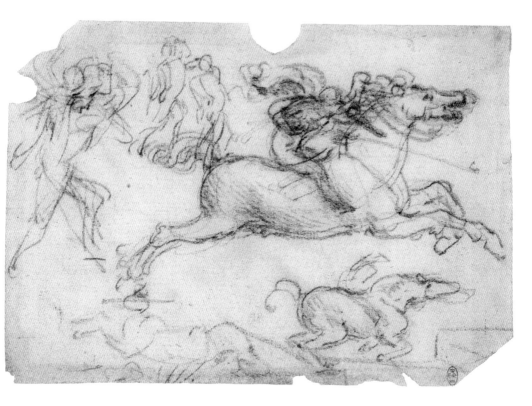

MACHINE GUN

Leonardo's designs for weapons and other machinery are particularly interesting in hindsight, because the ideas he had are very much those that exercised engineers and inventors during the 19th and 20th centuries. He foresaw the importance in warfare of heavy and light artillery, breech-loading firearms and multi-firing mechanisms to increase the rate of shot, all of which emerged in the latter half of the 19th century. With his interest in flying machines and parachutes, he also foresaw the aircraft revolution of the 20th century. The only thing that prevented him from producing modern weapons in his own time was the too-primitive technology and, more probably, the conservatism of the military leaders of the day.

This version of a machine-gun is a remarkable invention, given the problems of production. How well it would have worked is difficult to say, but theoretically everything has been thought through to an extraordinary degree. Leonardo's responsive mind obviously saw the advantage of firearms in battle, and he could see the problems of the contemporary weapons. His immediate response was to search for ways to improve their efficiency and range of powers.

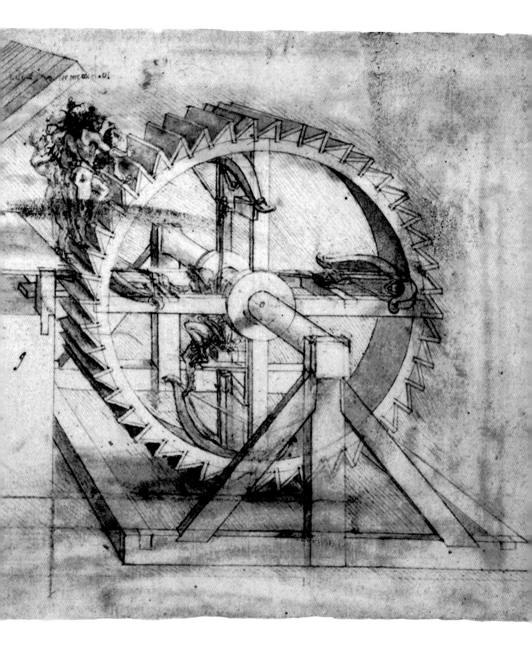

ONE-MAN BATTLESHIP

This device, in an extraordinary sketch dated around 1485, would have made the Duke of Milan's navy a world-beater had it ever been produced. It was designed to fire incendiary missiles at enemy ships and, as it required only one man to manoeuvre and fire it, a fleet of these machines would have pulverized their opponents. Again it is highly likely that nothing was ever made of the design, but Leonardo's imagination in the field of military endeavour was so fertile that if the technology of the time had been a little more advanced, and if the duke had been able to afford to take up his ideas, the history of European warfare might well have been altered. However, it was not to be; despite Leonardo's inventions being carefully preserved, they were not, as far as we know, put into practice.

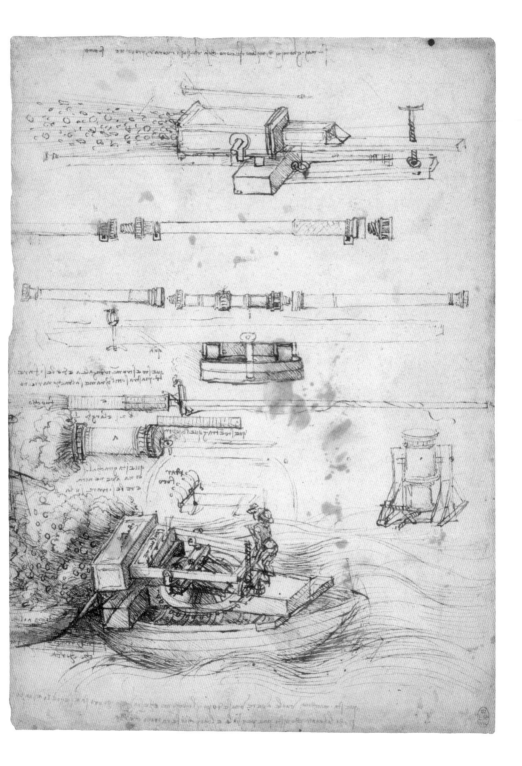

HORSE STUDIES

The projected painting of the
Battle of Anghiari resulted in
many drawings which give a
good idea of the behaviour
of horses in the arena of
conflict. This particular sheet
of drawings, dated around
1503–1504, concentrates
on the features of a horse's
head with two complete horse
figures, and a comparison of a
lion and a man whose features
are shown in a similar state of
ferocity.

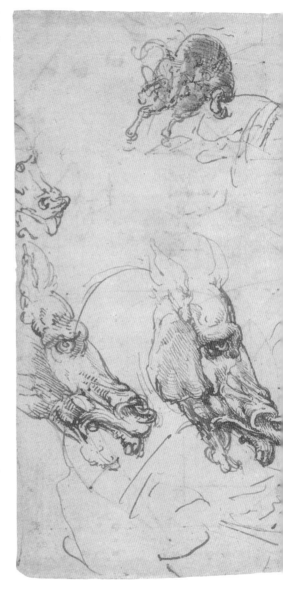

How graphically
Leonardo draws the mouth of
the horse with nostrils flared,
lips drawn back from the
teeth and the eyes in a state
of staring fervour! War horses
were trained to fight with teeth
and hooves, but must have
experienced terror as well.

The way Leonardo
lines up for comparison the
profiles of horse, lion and
man, with their distorted
grimaces, displays how he
was considering showing this ferocious battle scene. The caracoling
horse, rearing and tossing its head to one side, and the galloping
horse swerving in the fight – both give some idea of the activity and

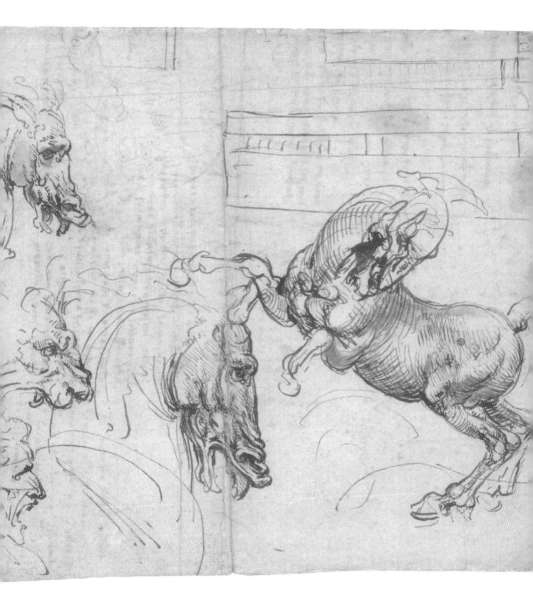

movement he was bringing to the composition. The horse studies are remarkable and have been used repeatedly since his time for the quality of rage they illustrate.

6

THE
DIVINE
SPIRIT

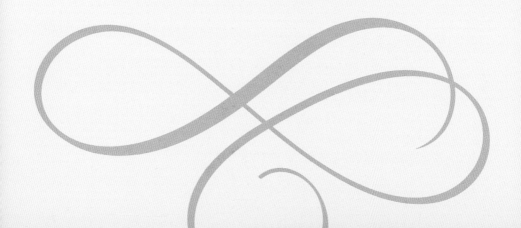

Leonardo's philosophy was one of unity: 'Every part is disposed to unite with the whole, that it may thereby escape from its own incompleteness.'

To Leonardo, the Creation itself was a united whole, beautiful and harmonious. It is little wonder, therefore, that in the contemplation of his great religious works the feelings that one is left with are harmony and peace: 'Do you not know that our soul is composed of harmony?' he wrote. Despite the frustrations that often attended his own life, Leonardo was certain of this fact. He painted out of the spirit of love, uniting with his subject in all its depth.

When he wrote about the role of the painter, Leonardo not only described painting techniques, he also wrote about how religious paintings are imbued with the power to bring to people health and happiness 'as if the Deity were present in person . . . You surely will agree that the image of the Deity is the cause, and no amount of writing could produce the equal of such an image either in form or in power'.

This was true in his day, when people would gather in multitudes to view a new work by the great Leonardo, and it is equally true in our own time. Though we may not share the religious imperative that once drove people to journey in search of spiritual revelation, we are still acutely aware of the genius of these paintings and the spiritual nourishment they provide.

In the portrayal of the physical world, Leonardo regarded painting as a science which brought 'philosophy and subtle speculation to bear on the nature of all forms'. With these words, he asserted that the role of the artist was not merely to represent physical forms, but also to connect with the world both in its outer form and in its essence.

STUDY OF THE HEAD OF CHRIST FOR
THE LAST SUPPER

It is essential to include this image of Christ for *The Last Supper* here. Although it is disputed that this is an authentic drawing by Leonardo, it does have many qualities of his work and resembles his final mural, as far as can be seen. The original has tempera retouching that may have been done by a student or assistant – common practice at the time. Even so, it is a beautiful and eloquent drawing that captures the moment when Christ forsees his own betrayal and death. The face is sorrowful, and at the same time calm and somehow dispassionate. The chalk lines of the features and hair are expertly drawn and the tonal shading is masterly.

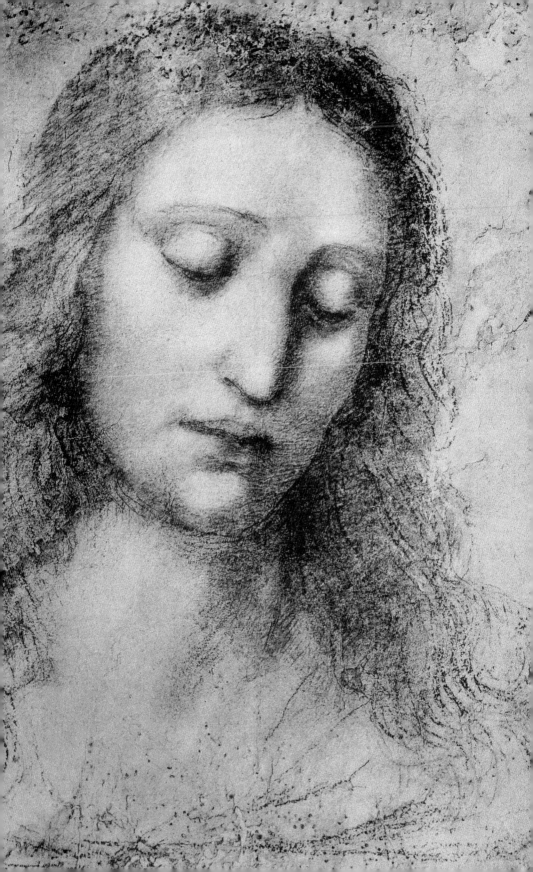

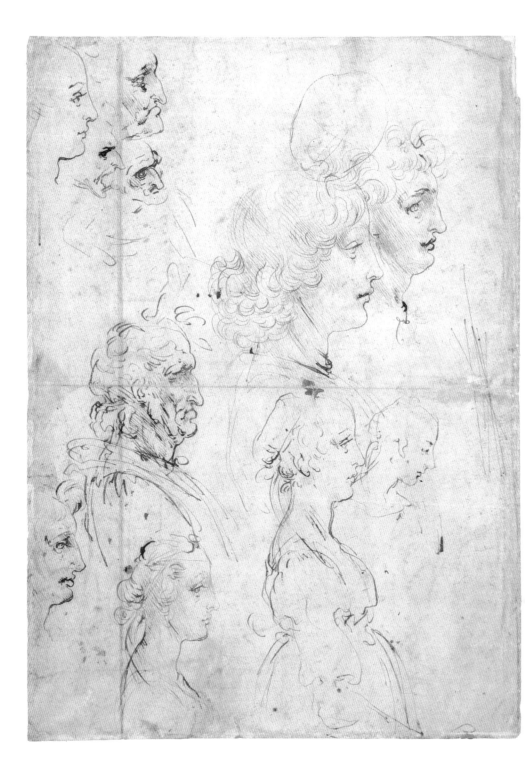

STUDIES OF PROFILES FOR *THE ADORATION OF THE MAGI*

The drawings in this group of profiles are thought to be for the unfinished *Adoration of the Magi* painting. These elegant portraits crowded together on a single page throw light on Leonardo's preliminary drawing when he was engaged in a major work. For *The Adoration of the Magi* there were many figures around the Virgin and Child, and also in the background. The variety of the human form and face interested Leonardo and he never drew two faces the same. For a large devotional painting such as this he would have required many types of face to draw from. Dated 1478–80, these drawings are executed in pen and ink.

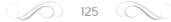

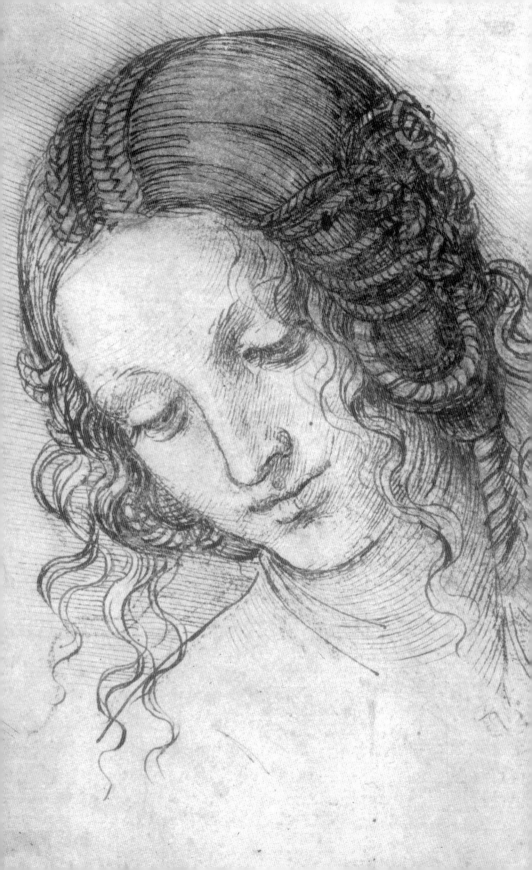

STUDY OF THE HEAD OF LEDA

This study of the head of Leda, dated around 1497 for the painting *Leda and the Swan*, shows the pains Leonardo took to transcend the simple portraiture of a character. When he was seeking a spiritual dimension in the final painting, as in this drawing, he would refine the features so that only the purity of the expression was left. This drawing shows a young woman with the tenderness of a mother as well as the modesty of a virgin. By a process of simplification and refinement, the final result is a profound image of the beauty, purity and tenderness of womanhood.

In the legend of Leda and the Swan, Zeus, king of the Greek gods, descended from Mount Olympus and took the form of a swan in order to seduce Leda, wife of the Spartan king, Tyndareus, beside the River Eurotas. This study of Leda's head, with the complex hairstyle reminiscent of Leonardo's drawings of flowing water (see p.58), associates the Spartan queen with the river and the aquatic bird who seduced her.

The beautiful modelling of the head, with its classical proportions and intricacy, displays the pains Leonardo would take to produce a final piece of work that left nothing to chance in its design.

BUST OF AN INFANT IN PROFILE

In this beautiful red chalk drawing of the head of a child, the age and tenderness of the infant are rendered in the sensitive strokes of hatching. The plump firmness of the cheeks and shoulders is clearly shown, as is the soft, fine, curling baby hair. This is a preliminary sketch for the painting *The Virgin of the Rocks*, where the profile of the infant Christ is almost exactly the same as in this drawing. The eyes in the painting look up more and the hair has been taken a stage further in development, as has the soft shadow which defines the three-dimensional qualities of the baby's head, but the likeness is so exact that it is clear this drawing is connected directly with the final work. Leonardo refines the natural purity and essential goodness of a small child to create an image of the infant Christ.

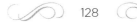 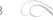

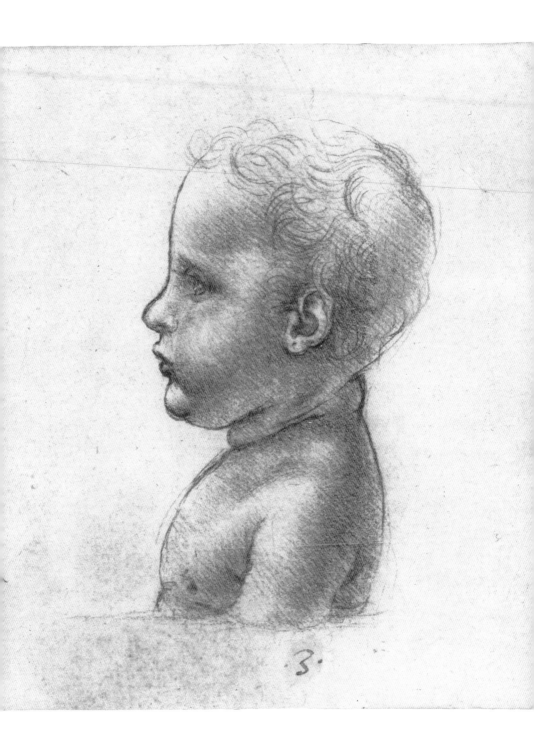

·3·

POINTING HAND FOR *THE VIRGIN OF THE ROCKS*

In another preliminary sketch for *The Virgin of the Rocks*, from about 1495, the soft quality of *sfumato* drawing gives this depiction of an angel's hand purity and tactile conviction. This angelic hand points towards St John, who is kneeling to the left of the Madonna, and indicates to the infant Christ what he is asked to do – that is, to bless St John. The drawing, in charcoal, is sensitive in emphasis, giving it a suitably ethereal quality. There are two versions of *The Virgin of the*

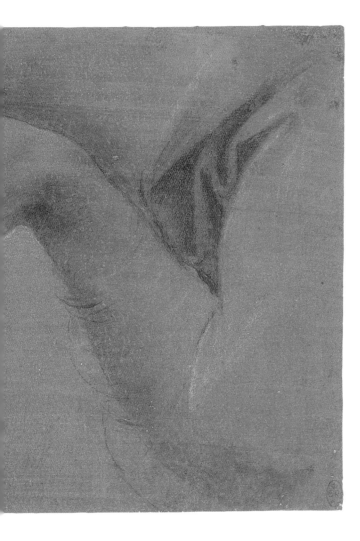

Rocks painting: the first is in the Louvre in Paris and the second is in the National Gallery in London, and the elegance of the hand has a feminine appearance that is more evident in the Paris painting than in the London one. It is interesting how Leonardo carefully formed the components of his compositions, each part in great detail, before assembling everything in the final cartoon. This is no ordinary finger point, but a manifestation of the thought of God.

STUDY FOR AN ANGEL'S HEAD FOR *THE VIRGIN OF THE ROCKS*

This study, dated 1483, is in silverpoint on prepared paper. Of all Leonardo's drawings this, with the *Head of Young Warrior, Shouting* (see p.112), is probably among the most polished and eloquent.

The drawing is of a young girl. As angels were deemed to be asexual, Leonardo made the gender of the figure more ambiguous in the final painting. This exceptionally beautiful face is powerfully presented with the eyes regarding the viewer directly but with a dispassionate gaze. The beautiful handling of the tonal hatching gives the whole head a three-dimensional quality and the drawing of the features is both subtle and vigorous. The soul of this young person seems visible in her eyes. The fluid, loose lines of the outline of the hair and figure emphasize the power of the face. What a remarkable artist this man was, that in so few lines he presents us with a living being. We are indeed seeing the divine spirit in the human face.

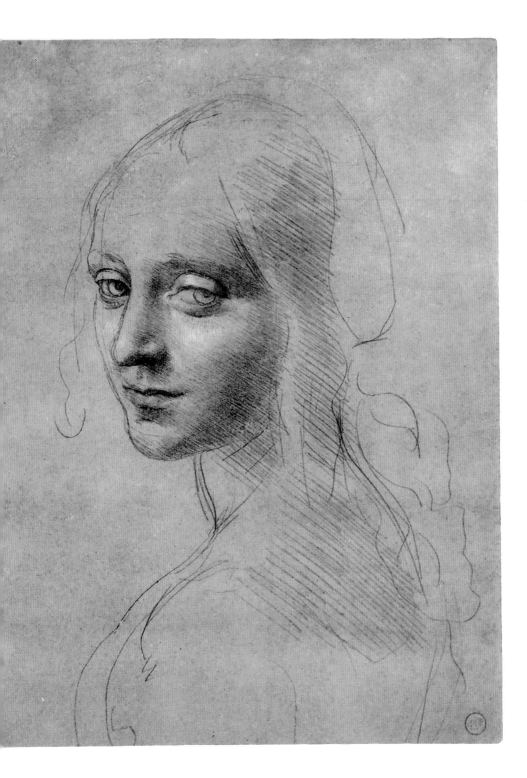

FIGURES FOR *THE LAST SUPPER*

This pen and ink drawing, dating from about 1496, is an early study for the composition of *The Last Supper*. In this version Judas sits with his back towards the viewer rather than in his traditional position on the opposite side of the table from Jesus. Part of the lower sketch shows Jesus and John, with Judas standing and stooping forwards to put his hand in the plate at the same time as Jesus. Thus, in the one series of sketches, Leonardo has two versions of how to place Judas and Jesus. Eventually he moved Judas to the same side of the table as Jesus and made the disposition and facial expression imply that Judas was the man about to betray Christ.

Even after several Renaissance painters had made excellent new versions of the Last Supper, the traditional arrangements still held well. But this was not a traditional rendering. In Leonardo's version, the animation and realism of the scene produce a revolutionary interpretation of the story. Nor did Leonardo place haloes over the heads of the figures: their very faces identify them as saints.

The painting was designed to fit the space available in the refectory of Santa Maria delle Grazie, so that the group of disciples appeared to be eating their meal where the monks ate theirs. The light in the painting also coincides with the direction in which light streams into the hall from the windows.

HEAD OF APOSTLE – ST PHILIP

In *The Last Supper*, St Philip is the third figure from Jesus on the right. He stands, indicating himself with both hands, as if asking if he could possibly be the one to betray his master.

The face of the drawing, dated around 1495, conveys the longing, adoration and sorrow of a young man faced with this dreadful prospect – that the perpetrator of the betrayal might not be aware of his impending crime. It is one of the most sensitive of Leonardo's drawings, without aggressiveness and redolent of the poetic gentleness of a lover. None of the other apostle drawings has this tenderness and simple adoration. It is a measure of Leonardo's greatness that he could take the faces of many characters and imbue them with different traits and emotions without repetition.

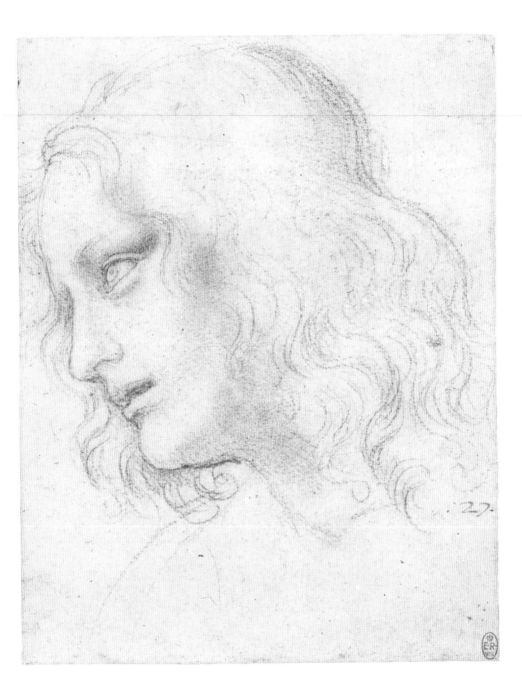

7

SYMBOLIC

THEMES

As someone of an Aristotelian frame of mind – who seeks to follow effects back to their cause in the laws that underpin the physical world – Leonardo saw causes manifesting themselves in all that he contemplated. He explored these manifestations mathematically, scientifically and artistically and perceived everything as part of a unified whole; the outer form manifested the inner principle. This is true for the composition of his paintings and it is also evident in his exploration and portrayal of symbolism and metaphorical subject matter.

Religious symbolism was central to medieval art and, with the rebirth of classical learning, a whole new symbolic vocabulary was discovered. Although Leonardo was an empiricist, taking nature as his subject, he could not avoid the power of symbolism. It may be that the interplay of light and dark in his painting, for which he was renowned and about which he wrote so extensively, had a symbolic significance.

The *Vitruvian Man* is the image that seems to sum up everything Leonardo stood for. This portrait of the 'Celestial Man of Light' represents the ultimate goal of humanity, balanced and in perfect harmony, a conscious being. If light is the hallmark of consciousness, Leonardo was its master, skilled at portraying the glowing beauty of the world's outer expression and its inner causes.

Whether in his religious paintings, his interior design or in designs for court entertainment, symbolic imagery was either an overt or implied presence. Again, Leonardo was acutely aware of the inner qualities everything possessed and was intent on portraying the interplay of these qualities. He wrote:

'Truth – the sun. Falsehood – a mask.

Truth in the end cannot be concealed.'

These pictures communicate how the symbolic fight between good and evil was viewed in Leonardo's day and one is left in no doubt that this was a fight to the death.

DESIGNS FOR ST GEORGE AND THE DRAGON

Dated around 1513–14, this sheet of drawings is of horses and dragons fighting, with St George as the rider of the main horse in the centre. Leonardo has invested the action with such liveliness, showing the beasts mingling and writhing around one another, that it produces an effect of maximum aggression and ferocity. The images of the horse trampling the dragon and the dragon's head curving round to bite the horse are imbued with the movement that Leonardo observed and recorded in his drawings of horses and other animals (particularly cats) from life.

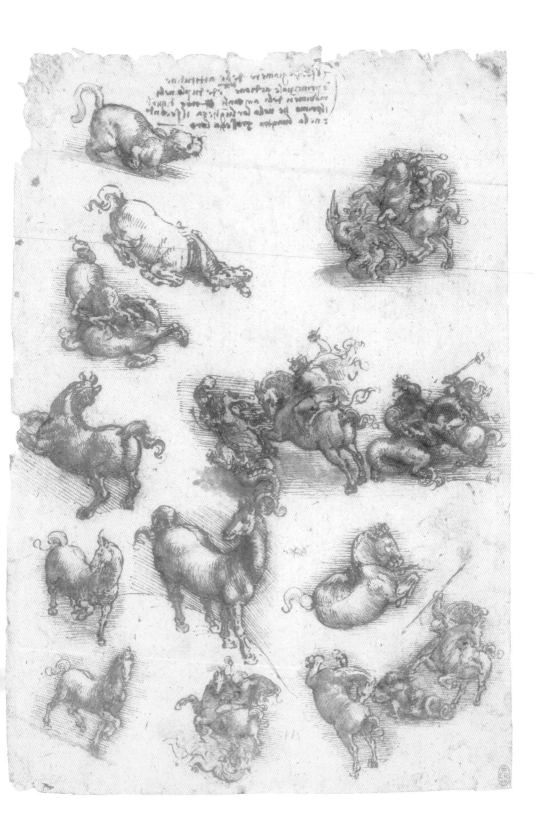

SKETCH FOR AN ALLEGORY

Here, in this strange figure, Pleasure and Pain are represented as
Siamese twins: they share one body up to the middle of the torso,
but have two pairs of shoulders and arms and two heads. Their arms
entwine, and the side representing Pain holds a large spiky plant
and scatters caltraps (metal dart-shaped objects), which were used in
battle to immobilize horses in the field. Pleasure, on the other side,
holds a long flowering staff in one hand and distributes what look
like rose petals on the ground. One of the figure's feet is in water
and the other is on a square slab. The head of Pleasure is a beautiful
youth with long, curly hair, and the head of Pain is a gaunt, stricken-
looking old man with wild hair and a scrawny beard. The youth's
head has an expression of delight and the old man's one of misery.
The hatching of the tone on the well-built body gives the figure
solidity and strength, and the firm undulating lines of the outline
give it life and movement.

WOMAN AND UNICORN

This drawing of a young woman, with a kneeling, docile unicorn which she has tethered to a tree, is known to be an early piece and there is not a great deal of information about why Leonardo drew it. The legend of the fleet and ferocious unicorn is that it cannot be caught by men, but if approached by a pure maiden it will immediately settle down and place its muzzle in her lap or hands. The trusting beast is caught only by purity or innocence. So, tradition has it that hunters would take a maiden along with them in order to deceive the animal, and when she had gained its confidence and tethered it the hunters would emerge to capture it. The unicorn's horn was supposedly valuable for its various properties, and it may also symbolize the idea that only a woman can deceive nature into giving itself into captivity.

This exquisite drawing in pen and brown ink is small, but, as ever, Leonardo contrives to include all the elements necessary for a lively, attractive picture.

THE POINTING LADY

This study, dated around 1513, is sometimes thought to represent a masquerader, similar to those in other of Leonardo's drawings from life. This, however, is unlikely, as the sketch includes a landscape setting rather than an artificial background. The foreground and background are connected by the stream, which curves round into the depths of the space. It is a beautiful representation of a garment being folded and ruffled by the breeze, like turbulent water. According to Leonardo, the posture, probably inspired by antique models, imitated the 'Greeks and Latins in the manner of revealing the limbs when the wind presses draperies against them'.

The figure is directly related to the landscape by the suggestion of the wind which blows against her as she points into the distance. What she is pointing at while gazing at the viewer is not known. This sort of gesture in a work of art was intended to convey the connection between the viewer and the event in the painting. The prominence of her position suggests that she must be either a goddess or an allegorical figure.

HEAD OF A MAN WITH LIONSKIN

Dated around 1503–1505, this highly detailed and well-modelled red chalk drawing shows the powerful, aggressive face of a warrior, although the vine leaves in his hair might suggest Bacchus or a follower. The suggestion of a lionskin over the man's left shoulder could indicate a connection between the man's physiognomy and the lion's head or it could refer to an image of the demi-god Hercules, although the man's age would suggest otherwise. The man's face is definitely leonine in quality and the lionskin highlights this characteristic. Is this a symbolic representation of a character type or a representation of one of the gods of classical mythology? Or merely a sketch that started as a bust or portrait, became Bacchus when some vine leaves were added, and then Hercules with the rough sketch of a lion's head on the man's shoulder? We can only speculate that Leonardo, in common with other artists, liked to build up pictures as the mood took him, and his notebooks would have been the ideal place for such creative expression.

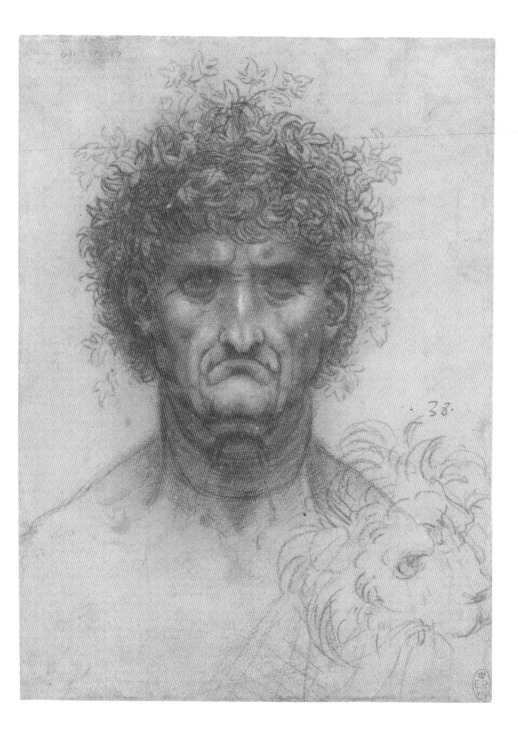

38.

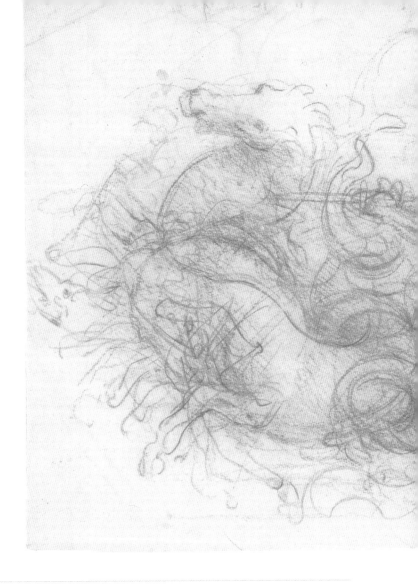

NEPTUNE GUIDING HIS SEA HORSES

Another piece of Renaissance symbolism, this picture dates from
around 1503–1504. These beautiful, rearing, vigorous sea horses,
with equine heads and forelegs and bodies tailing off to fins and
curling fishes' tails, are moving in four different directions. In the
centre, the great figure of the god of the oceans, Neptune, wields his
trident and grasps a harness between the horses' heads. Presumably
these figures would have been rearing up out of waves, although
there is no indication of the sea in the drawing. This might have

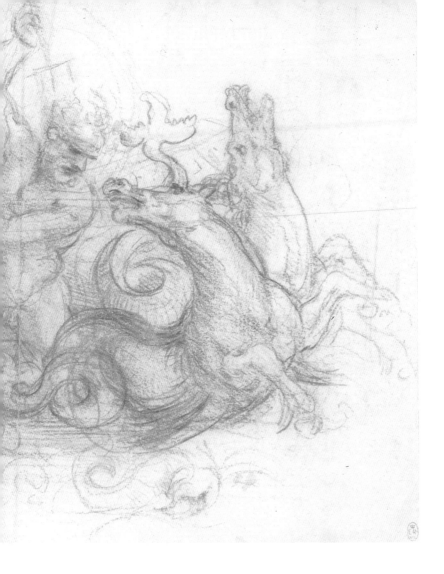

been a sketch for the design of a fountain like the great Neptune fountain by Ammanati in the Piazza Signoria in Florence. However, Leonardo usually sketched the workings of such devices alongside his designs, so this may have been for some other painting with a mythological theme. The beauty of the black chalk drawing results from its Baroque vigour and the flowing ease of expression in the loosely drawn lines and tonal modelling.

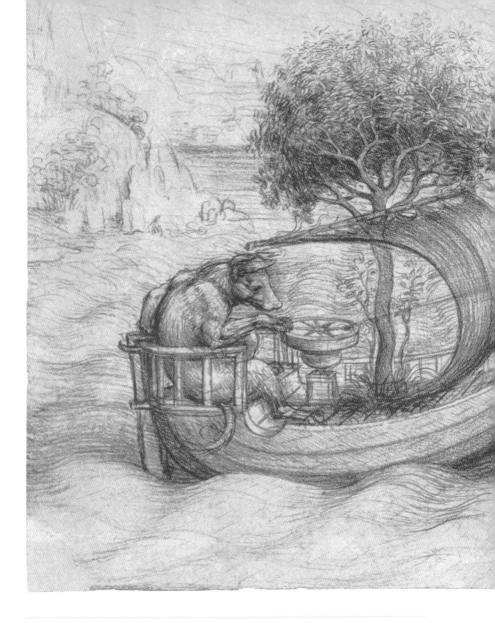

ALLEGORY: BOAT, WOLF AND EAGLE

The extraordinary symbolism of this picture, dated around 1513–16, probably refers to the wolf as the Church, which is in charge of the boat with its living tree and compass. Does it suggest that the wolf – a rather negative image for the Church – is given too much direction over the life of man? The Pope and the German Emperor were rivals for power at this time, and in Italy the great families and

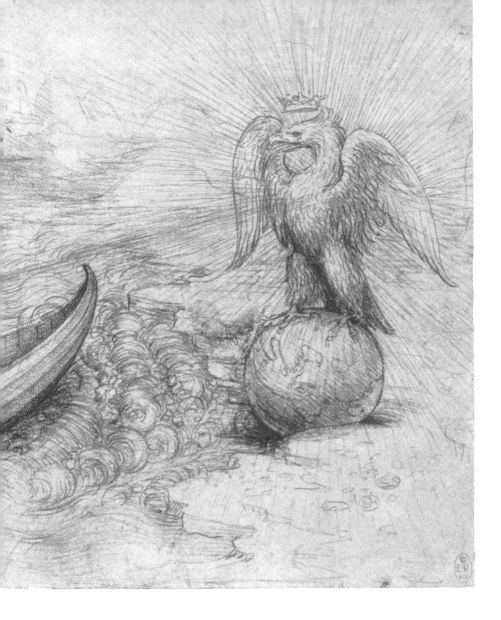

political leaders were divided between the two. The shining eagle may suggest that the Emperor is a leading light in the world. And why is the Church sailing towards the land and what is, presumably, the German Empire? Either way, it is not difficult to second guess where Leonardo's own sympathies lay.

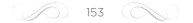

THREE DANCING WOMEN

This remarkably vivid design of three dancing women is sometimes believed to represent angels dancing at Christ's nativity. But it is also associated with the drawing of the Pointing Lady, and one wonders whether this could be connected with the Three Graces, a popular image during the time of Leonardo's youth. The figure on the left holding a drape above her head in an arc was often associated with the goddess of fortune or the night. So this could instead be a drawing connected with the symbolism of the ancient world: the three figures symbolizing the beauty of heaven, the desire for that beauty and the active desire to return to the source of the beauty. Leonardo probably knew of Botticelli's *Primavera* painting, which features the Three Graces prominently, and he may have been experimenting with his own version of a similar design.

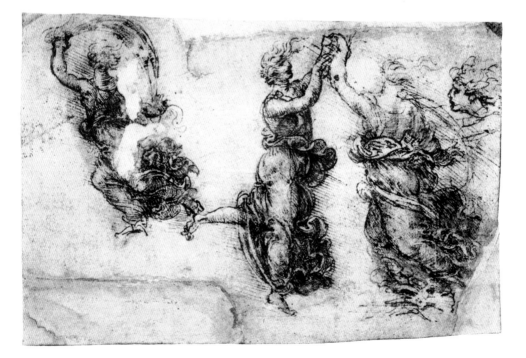

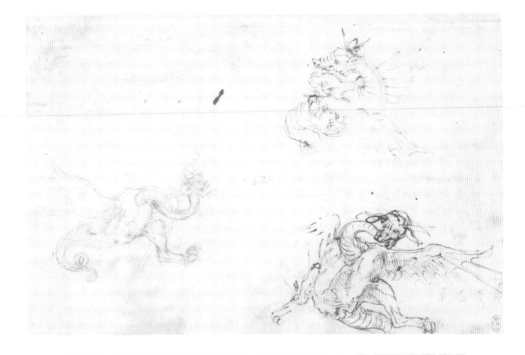

DRAGON

These drawings of writhing dragons, dating from around 1480, give some idea of Leonardo's thinking when he approached an awe-inspiring animal, especially of the fantastical kind. He uses his understanding of how other animals move to depict the ferocious, curving shapes of these mythical creatures. Thus they seem to have a genuine existence, while also being symbols of lust and cruelty. The bat-like wings, serpentine, scaly body armed with claws and gaping mouth with sharp teeth are skilfully combined. The ability to imbue a symbol with such terrifying life was a measure of his genius.

HORSEMAN ON TRIUMPHAL ARCH

This study, dating from around 1508–1511, is for a monument to
Gian Giacomo Trivulzio which was commissioned on the capture of
Milan by the French (Trivulzio was one of France's leading soldiers).
The French marshal commissioned Leonardo, but the work never
got to the point of being realized in clay because the French were
expelled from Milan. However, on their return in 1506 the project
was resumed, and this drawing dates from that time. There are other
similar studies.

The vigorous, three-dimensional effect of the *sfumato* drawing
with the gallant rider and horse trampling their foe was a symbol
used time and again to depict victors in war. Although there are
many drawings associated with this symbol of French power over
Milan, the final work never reached completion because, as with so
many of Leonardo's projects, other commissions took over.

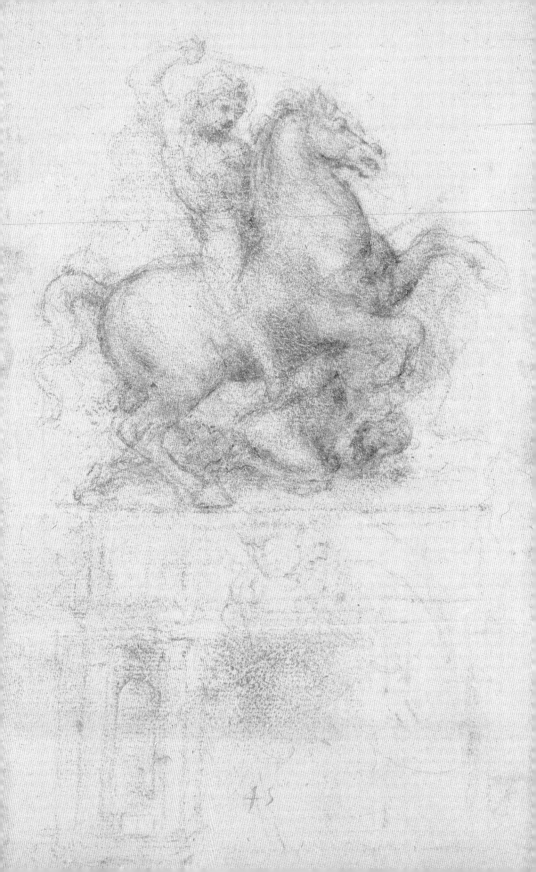

COSTUME FOR FESTIVAL PARADISO

Leonardo produced costume designs for the wedding of the Duke of Milan, Lodovico Sforza, to Beatrice d'Este in 1491. The symbolism of the costumes is not precisely understood, but this young man in stylish Renaissance costume, with long draped sleeves, a spotted and slashed doublet, a feather in his headdress and holding a lance, is one of the figures that has survived. No doubt the images were symbolic of the great prowess of the duke or the illustrious forebears of the new duchess.